QUEENS

DOUBLEDAY

New York London Toronto Sydney Auckland

QUEENS

Portraits of

Black Women and Their

Fabulous Hair

Michael Cunningham and George Alexander

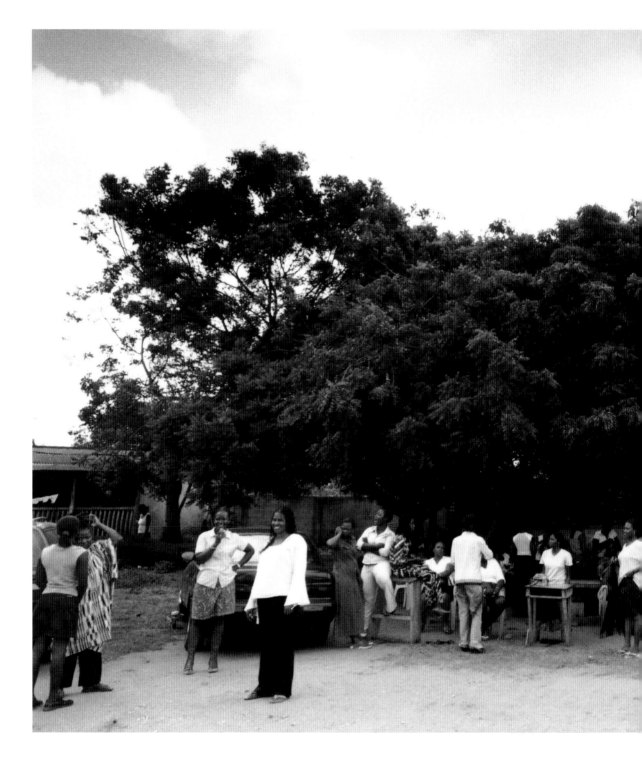

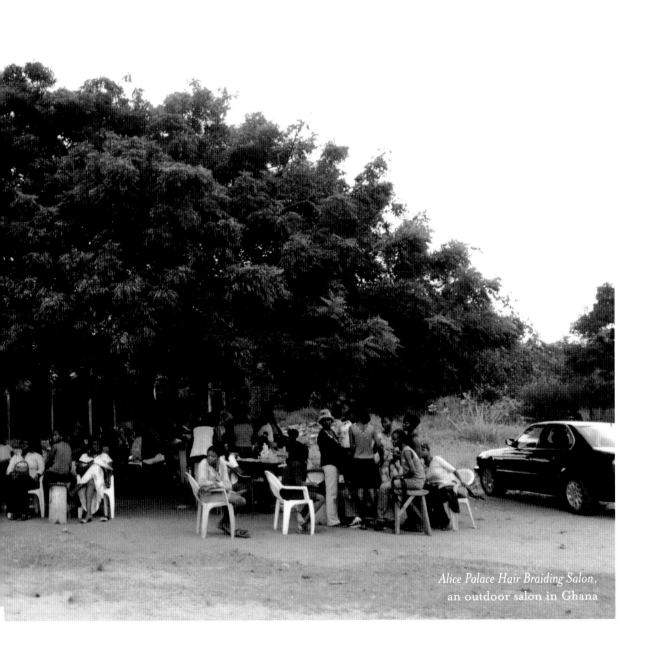

Alice Palace Hair Braiding Salon,
an outdoor salon in Ghana

PUBLISHED BY DOUBLEDAY

a division of Random House, Inc.

DOUBLEDAY and the portrayal of an anchor with a dolphin are

registered trademarks of Random House, Inc.

Book design by Jan Derevjanik

Library of Congress Cataloging-in-Publication Data

Cunningham, Michael

Queens : portraits of Black women and their fabulous hair / Michael Cunningham and George Alexander.—1st ed.

p. cm.

ISBN 0-385-51462-X

1. Portrait photography. 2. Photography of women. 3. Women, Black—Portraits.

4. Women, Black—Interviews. 5. Hairdressing of Blacks. 6. Hairstyles—Pictorial works.

I. Title.

TR681.W6C86 2005

391.5—dc22 2005042030

PRINTED IN JAPAN

December 2005

FIRST EDITION

1 3 5 7 9 10 8 6 4 2

TO OUR HAIR QUEENS:

Our ancestors, grandmothers, mothers, aunts,

sisters, daughters, nieces, and godmothers

AUTHOR'S NOTE

BLACK WOMEN AND THEIR HAIR PLAYED A SIGNIFICANT ROLE
early in my life. I recall being a small boy of about four or five in Mobile,
Alabama, hanging out in my late aunt Gertrude's beauty shop, which was
adjacent to my maternal grandparents' house where I lived with my parents,
older sister, and brother. Nana Gert, as she was affectionately called by
everyone, was a sweet but feisty, no-nonsense woman with a wicked sense of
humor, who began hairdressing in the mid-1930s. Crippled by polio as a
child, Nana Gert was encouraged by my grandfather to stay in Mobile to
study hairdressing rather than venture off to college like her siblings. But
she got a different kind of education. In Gert's Beauty Shop she developed
a keen insight into all types of folks, making her an excellent judge of char-
acter and a trusted confidante. In my teen years, I told Nana Gert things I
dared not tell my parents. Nana Gert never judged. She just listened. In her
salon, she'd heard and seen just about everything.

Even though I had been exposed early on to what hair and hair salons
have meant to Black women, I never dreamed that I would do a book about
Black women and their hair. Yet life unfolds unexpectedly, and frequently the
good things in life, the best stories, are right there in our very own experi-
ences, in our very own lives. We have only to listen and pay attention.

The year 2003 had been exciting but most challenging for me. Despite
the blessing of having my first book published—*Why We Make Movies*—I was hun-
gry for work, but good ideas and promising projects seemed to elude me; I
was merely walking on faith.

One chilly evening in November 2003, shortly before Thanksgiving, my faith walk led me to the much-celebrated Studio Museum in Harlem to a book signing for Craig Marberry and Michael Cunningham's *The Spirit of Harlem*. I was hoping to be inspired.

Before the signing, I chatted with Craig and Michael about their project. I had only recently met Craig, a fellow Morehouse man, a few weeks prior during our homecoming weekend in Atlanta; Michael and I were meeting for the very first time. It was during their excellent presentation on *The Spirit of Harlem* that I felt I wanted to find a photographer and do a photo-essay book. I had bounced around ideas in the past, but this time I was determined. Yet I hadn't a clue of what the subject matter might be.

The next week, it came: a photo-essay book on African American ministers popped into my mind. I was on fire. I eagerly phoned my phenomenal agent, Victoria Sanders. She informed me that Michael Cunningham had already pitched the very same idea to her months before and that perhaps the two of us could collaborate on the project. Michael and I discussed the idea and immediately decided to work together on *Ministers*. We ultimately lost out to an outstanding photographer/writer team who had already delivered a similar book proposal to our publisher, but we refused to be discouraged. Admittedly, I was crestfallen, but I had a sudden boost of confidence. I knew that Michael and I worked well together and I knew there had to be an idea on which we could collaborate; we had only to remain patient, passionate, and resolute. A few days later, Victoria, in her brilliance, phoned us with the idea

for *Queens*. I knew then that *Ministers* not working out was a blessing in disguise. *Queens* was *our* project. Michael and I knew we were on to something great. And great it has been.

From the photo shoots and interview sessions conducted in my Harlem apartment; to our shoots at salons along the Eastern seaboard; to Central Park; to a hair braiding school, a colonial fort, and a marketplace in Ghana; to hair shows in New Jersey, London, and Atlanta; *Queens* has been one of the most extraordinary and cherished experiences in my life.

The journey to making *Queens* has been fun, exciting, invigorating, challenging, at times painstakingly frustrating, and often full of moments of unquenchable laughter. There were long days and long nights, but the work was always carried out under an umbrella of unimaginable joy.

Working on *Queens*, Michael had the privilege to photograph and I had the opportunity to interview some of the most intriguing women I have ever encountered. Amazing women shared their hair stories and their lives with us. I learned that, particularly for Black women, hair is so much more than just hair. Hair has the ability to unleash all of life's deepest emotions. Hair is about identity, beauty, racial pride, race politics, self-acceptance, self-expression, self-realization, class, status, fun, glamour, romance, fantasy, art, passion, joy, pain, freedom, enslavement, power.

Hair can be all those things and more.

For Black women around the globe—from the villages of Ghana to the Seychelles, from Brixton to Roxbury, to Bedford-Stuyvesant, to Sugar Hill,

to the Alabama Gulf Coast—hairstyling has provided economic empowerment and advancement. Hairstyling has been a bridge from darkness to light. It has bought children's Easter clothes and paid for college tuition. For some women, getting one's hair pressed and curled or making the decision to go natural has been a rite of passage, a ritual, a coming into one's own sense of place in an oftentimes hostile world that has frequently denied the Black woman her rightful place in the beauty spectrum.

One of the most fascinating things I saw in Ghana were the many school-girls dressed in crisp school uniforms with angelic short-cropped Afros. I later learned from some of our subjects that many of the schools in Ghana require that young girls up to about the age of eighteen (in some cases) keep their hair short so as not to distract them from their studies. In other words, to get schoolgirls to think only about their studies and not become preoccupied with their hair, someone had a solution: "We'll make them cut it all off." I immediately thought, "Mmmm, I wonder if that would work back in the States?"

As our book progressed, I was again reminded of the multifaceted beauty of the Black woman. She is beautiful in her locks. She is beautiful in her cornrows. She is beautiful in her silky straight perm; in her naturally straight hair; in her soft Afro; in her colorful carnivalesque fantasy hairstyle; in her wild and crazy party do. She is even beautiful in her kinky naps. She's just plain beautiful. A Queen.

Here's to Black women everywhere!

GOD BLESS,
GEORGE ALEXANDER

PHOTOGRAPHER'S NOTE

WHEN MY AGENT, VICTORIA SANDERS, TALKED TO JOURNALIST George Alexander and me about doing a book about Black women and their hair, I knew it would be a wonderful journey. She immediately got our brilliant editor, Janet Hill at Doubleday, to embrace the idea and then George and I went to work uncovering this fascinating subject.

As it turns out, Black women and their glorious hair is a topic that I'm quite intimate with, having grown up with five beautiful women in my life: my mother, Patricia, and my four sisters, Brenda, Juanita, Ersel, and Taricia. Hot combs, curling irons, rollers, and relaxer kits were in abundance in our household. On Saturday nights the kitchen would become a salon and would transform limp and frizzy hair into works of art for Sunday church service and the rest of the week.

Later, when I was in high school in Riverdale, Maryland, a prerequisite to dating some of the girls was taking care of their weekly hair salon bills!

How did we find the women who appear in *Queens*? With the help of several friends, George and I stopped women on the street, peeked in beauty salons up and down the East Coast, and attended the "heaven" of the black hair industry: the hair shows in Secaucus, New Jersey; Atlanta, Georgia; and London, England. My biggest concern while covering the hair shows was that I would run out of film and not be able to record the many elaborate hairstyles of the women there.

During each photo shoot, I would try to zero in and reveal what each woman was saying with her hair. The right lighting, location, and ambiance

were carefully chosen to make each woman and her hairstyle look her best. The textures, layers, and dimensions of the hair were very important to me because a woman's hair has been said to be her crowning glory. With George conducting the interviews and giving a voice to the images of our hair queens, I was assured that we would be successful in creating a book that would convey the passion that black women have about their hair.

While working on this book I spent hours in hair salons photographing the hair "scene." Sometimes the atmosphere in the beauty shop was hurried; at other times it was peaceful. But for the most part there would be lots of conversation, hair everywhere, water flowing at the shampoo bowls, frustrated little girls and boys waiting for their mothers, sisters, grandmothers, aunts, and cousins. Women in rollers and hairpins would be sitting under hair dryers perusing the latest novels and magazines. I still can't believe that so many black women go through this weekly ritual of activity and time spent in the salon all in the name of beauty. But I'm glad they do.

I am blessed to have been able to travel to Europe and West Africa to capture the Black hair queens there. It was amazing to see the cultural transference across continents: how some traditional Ghanian hairstyles echoed the hairstyles found in urban America, or how women in London hair shows sported the Afro and other hairstyles with a degree of artistry, abandon, and flair reminiscent of the USA circa the 1970s. While working on *Queens*, I learned that the importance placed on a well-thought-out "do" unites Black women throughout the world.

My daughter, Kamari, who is now thirteen, taught me a lesson when she was five years old. She made me aware that the ponytail I was famous for creating for her (in truth, the only hairstyle I knew how to do save sticking a hat on her head) was just not enough for a hair queen. As a result of my inability to do her hair she started to "fix" her own hair. Kamari reminded me of the lessons I'd learned as a young boy about how important a woman's hair is and that it's not something to take lightly. . . . See for yourself as you turn the pages and discover *Queens: Portraits of Black Women and Their Fabulous Hair*.

MICHAEL CUNNINGHAM

QUEENS

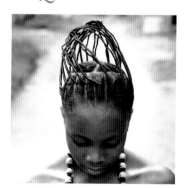

My advisor . . . said, "Your name is A'Lelia.

Do you have any connections to A'Lelia Walker or Madame Walker?"

And I said, "Yeah, they're my great-great-grandmother

and my great-grandmother." She said,

"That's what you're going to write your paper about."

A'LELIA BUNDLES

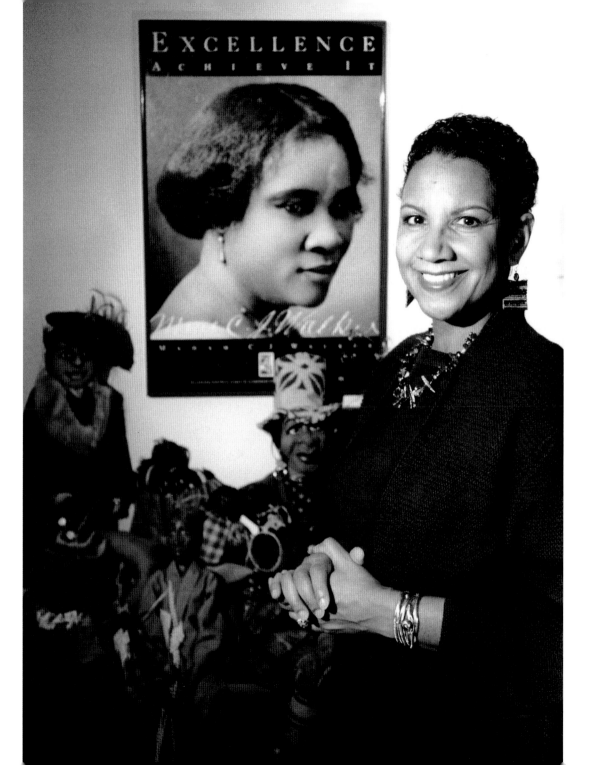

AS A CHILD GROWING UP IN INDIANAPOLIS, I WAS TOO YOUNG to really appreciate everything my great-great-grandmother Madame Walker did as a hair products entrepreneur, philanthropist, and political activist. I was just a kid playing in a dresser discovering things that had belonged to her and her daughter, A'Lelia Walker.

The first time I had my hair pressed was at the Walker Beauty Shop for the sixtieth anniversary of the Walker Company. People came from all over the world. When they cut the ribbon to open the celebration I was standing there and my hair was pressed, it was all down my back.

Then came the late sixties. The day that Martin Luther King, Jr., was assassinated I was elected vice president of my high school's student council and my school was 95 percent white. The next day some white parents called the school and said that they were going to take their children out of the school because I was elected. That was the beginning of my "real" personal radicalism and my Black identity. I read *The Souls of Black Folks* by W. E. B. DuBois and that was particularly important because it was the first book I read that truly deconstructed race and power in America. That book transformed me. I was going through this identity transformation and hair was very much a part of that. In my household there was a big battle about whether or not I could have an Afro. My father, as president of Summit Laboratories, which made hair-straightening products, said, "What do you mean you're going to get an Afro? Who do you think pays the mortgage and tuition?" It was an intense battle. My father traveled a lot to hair shows and he was leaving town and I had a nightmare. I was screaming. I had

to get an Afro. The next day my father called and he and my mother must have talked because he got on the phone and said, "Okay, you can have your Afro."

My mother took me to the Walker Beauty School and the students rolled my hair up and created this huge Afro for me. I had always had long hair, big braids, crinkly, wavy hair, and I'm proud to say that I have all of my ancestors in my hair, but in the era I grew up in, people only valued whatever part of your hair that was straight. With long hair people did say I was cute, but with my Afro I was considered strong. The older I get the more I realize that what endures is "strong," not "cute."

After I graduated from Harvard I later went to graduate school at Columbia to study journalism. My advisor was Phyllis Garland, who was the only Black woman on the faculty at the journalism school. We sat down to talk about my final project and I threw out some lame topics. But she said, "Your name is A'Lelia. Do you have any connections to A'Lelia Walker or Madame Walker?" And I said, "Yeah, they're my great-great-grandmother and my great-grandmother." She said, "That's what you're going to write your paper about." She was such a blessing to me because if I had had any other advisor they would have looked at my name and thought, "This is a weird colored name this girl has." But Phyl validated my name and my family history. People had told me before that I should write about Madame Walker, but no one like Phyl, who was a role model and a published journalist, who said that it was an important story and told me you're *going* to write it, and I'm going to support you in the writing of it.

An Afro to me means natural Black beauty.

ANITA NORGROVE (LEFT)

*Monday through Friday I work for a pharmaceutical company
as a research scientist. I've always wanted to make
my own hair-care products.*

LINDA EGWABOR (RIGHT)

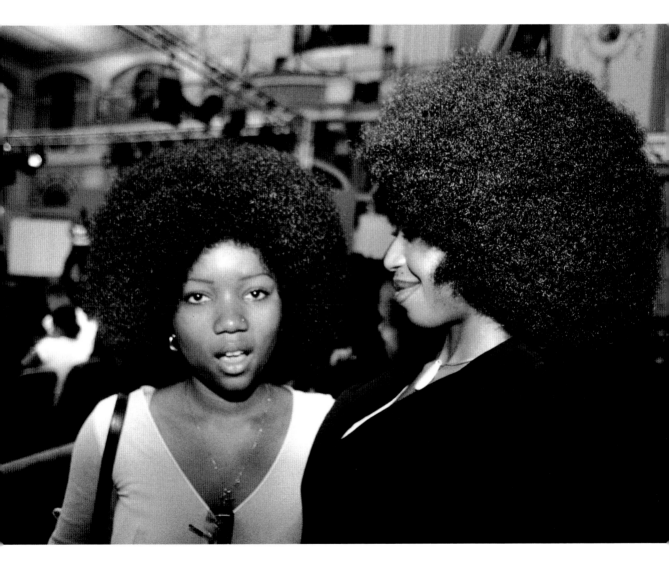

ANITA NORGROVE, 17

{Hairdresser and High School Student}

I WAS BORN IN AFRICA, BUT MOVED WITH MY FAMILY TO LONDON when I was small. My mom is from Nigeria and my father is from the U.K.

People don't see me in an Afro normally. I usually wear my hair in corn-rows or braids. Where I live you don't walk around town in an Afro if you're a girl. They'll make fun of you. On Saturday I went into a pub and everyone was laughing at me. It was mostly white people. Maybe they just find it funny. Most white people will just laugh because my hair is a different texture than theirs. I just laugh with them. I don't want them to think I'm upset.

An Afro to me means natural Black beauty. A Black person who has an Afro, and who has the nerve to walk around the street in it, means that they're proud of their own natural beauty. They're not ashamed of it. I'm not ashamed of my natural look. When I wear braids people always ask me if it's my real hair. When I get my hair braided I get extensions because I want my braids to be long. But that's the only thing that's ever not real on me. Apart from that, I don't wear makeup. No makeup for me. I'm proud of the way I look. I'm happy with my weight, my figure, and my height. People should try to look as natural as possible and not worry about what other people think because that's the way you were created.

LINDA EGWABOR, 23

{Research Scientist and Hairstylist}

I GREW UP IN LONDON. I'M THE OLDEST OF FIVE CHILDREN. My mom couldn't do hair to save her life. I was about eight when I started doing my own hair. When my mom styled my hair as a child, I used to wait until the last minute and go back in the house to change it. At first she had a problem with it, then she realized that I might have a talent in hairdressing. Then I started learning to braid and I'd braid my own hair. I used my mom a lot as my guinea pig, and people liked what I'd do; she got me lots of clients. I was self-taught. I was always in front of the mirror.

When I was thirteen or fourteen, I came across a book in the library on Madame C. J. Walker and learned about what she went through in getting her product to the market; it was all very interesting to me. From all of the information I read about her I think that's what got me more into hair and beauty.

Monday through Friday I work for a pharmaceutical company as a research scientist. I've always wanted to make my own hair-care products. I always used to use a lot of gel. My aunt walked into my room one day and said, "What would you do if you actually ran out of gel?" I said, "I'd have to learn to make my own." That's how my interest started. I've always had a fascination with science. I just wanted to incorporate what I've learned in science with hair, to come up with something new and different. Because I do hair, I know what I want, so if I can go to the theory part of things, to the stem of things, my dream is to combine them together and come up with something that other people are also looking for. My dream is to have my own hair-care products and cosmetics company. And I do believe that dreams come true.

. . . Wearing the Twin Towers is an honor.

My cousin . . . , who was twenty-six years old and

a mother of two, died . . . on 9/11.

Jennelle Byron

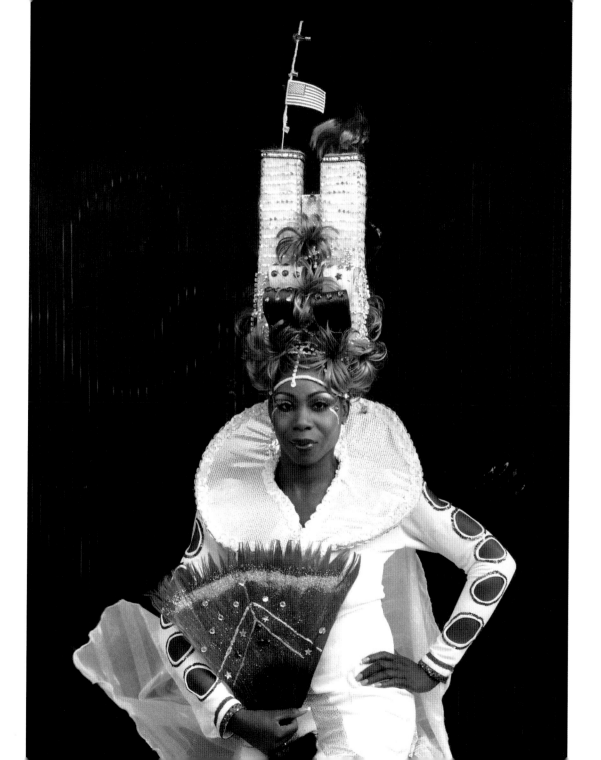

JENNELLE BYRON, 23

{College Student}

I GREW UP IN BROOKLYN, NEW YORK, WITH MY MOTHER AND father, who are both from the island of Nevis in the Caribbean. I love fashion, hair, and modeling.

My mother started doing my hair when I was young because I've had long hair from birth. My hair has always been straight so I have never had to deal with naps. I have done my mother's hair since I was big enough to pick up a comb. As a little girl I would always play with my mother's hair and put styles in it. It was a great way for me to bond with my mother. I still do her hair to this day.

As a little girl I always watched Shirley Temple movies and I loved how her curls bounced and I wanted my hair to be just like hers. So for my eighth grade prom at St. Thomas Aquinas School, a Catholic school in Brooklyn, I was able to get my hair exactly like Shirley Temple's hair. At St. Thomas the school didn't allow us to have extremely outrageous hairdos, so every day I wore my hair in a bun or in pigtails and it was always very neat.

In the early nineties there was a hairstyle called the flamingo. You would wear your hair back in a ponytail then stiff the ponytail with gel and have it stand up like a flamingo's tail. Most of the girls who got the style had short

hair and it was easier to do the style with short hair. But a friend of mine wanted to give me a flamingo, so she put a lot of gel in my hair. But because my hair was long, it wouldn't stick out like a tail. It looked ridiculous. I had no mirror to see what was going on and I told her that I didn't like it, but she told me that I looked pretty. When I got outside, everyone laughed at me because it didn't look right at all and I couldn't get it out. When my mother got home I got in trouble for letting my friend play with my hair.

Working with Veronica Forbes, the stylist who designed the Twin Towers I'm wearing, makes me feel like an actress playing a role. I know I don't look like myself when I wear this outfit and that makes me feel good. It's great to step out of your own shoes into something else. It's fun and exciting.

And wearing the Twin Towers is an honor. My cousin Claudia Sutton, who was twenty-six years old and a mother of two, died in the World Trade Center on 9/11. It was a difficult time for me, for the country, for the world. Wearing the Twin Towers brings back good memories because the hairstyle is uplifting. It's white and silver and sparkles. It gives you hope. I have hope for the world. I have friends overseas in the war and I pray every day that God will bring them home safely.

I could write a book about the salon. People have come in and said

that they'd like me to do their hair but that they only have

half the money . . . I said,

"Yes, I'll do your hair but I'll only do half your head,"

and they looked at me like I was crazy.

∞

Veronica Forbes

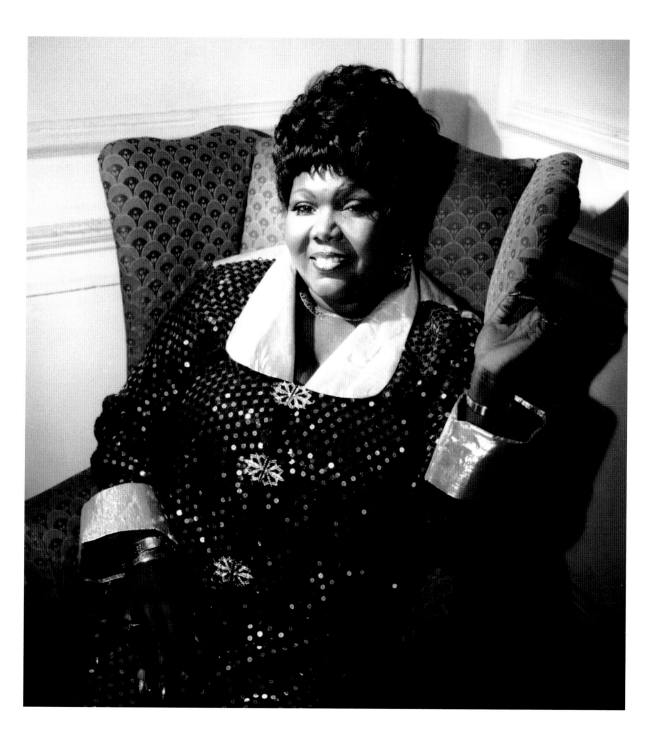

VERONICA FORBES, 52

{Beautician}

I'VE ALWAYS WANTED TO BE A BEAUTICIAN. WHEN I WAS growing up in Jamaica my mother would send me to the beauty salon and if the beautician told me to come at noon, I would tell my mother that the appointment was at 10:00 a.m. just to get there early, so I could help the beautician because I've always been fascinated by hair.

I came to New York from Jamaica at fifteen and went straight to beauty school at Wilford Academy in Brooklyn. I was one of the top students there because I was anxious to learn. I was the first one to put my hand up and my teacher idolized me because I would arrive early and would be the last one to leave.

I graduated from Wilford in 1975 and after working with a number of other stylists, I opened Veronica's Beautyrama in Harlem in 1980. I never wanted to be an ordinary beautician. I wanted to work on the stage and on the movies. I was a stylist on a film. That was so exciting; it was the peak of my career.

In the early 1990s I decided to pursue fantasy hairstyling. Fantasy hair is creative. It's creating anything you want. Someone comes to you and says that they want a replica of the George Washington Bridge and it has to be all in human hair. That's fantasy hair.

I was inspired to do the World Trade Center Twin Towers design worn by Jennelle Byron right after 9/11. I had gone to Chicago to do the Proud Lady Beauty Show and the towers had just fallen. I'm from New York and I wanted that feeling to stay with me. I wanted people to know where I was coming from. I felt emotionally connected to the World Trade Center because I lost

two customers who worked there. The Twin Towers are very close to my heart. The design won second place at the competition.

Tisch Sims's hair is in my hair design that I've named *Purple Passion*. I love the color purple. At the hair shows I'm always in purple from head to toe and I'm known as the Purple Diva. Purple represents royalty, passion, you name it. You can go to any hair show and ask anybody if they know where the purple lady is and they will take you to my booth.

I could write a book about the salon. People have come in and said that they'd like me to do their hair but that they only have half the money, but would I do their hair. I said, "Yes, I'll do your hair but I'll only do half your head," and they looked at me like I was crazy. You have half the money, I'll do half your head.

Then you have people who are bald in the front but want a weave off the back and I won't do a job like that and they get mad at me. I have a slogan that I use. I tell them, "You want that done you can go down the block to Big Mary." They'll ask me, "Who's Big Mary?" I'll say, "Keep walking until you find one. Somebody will do the job, but Veronica's Beautyrama won't." As a professional you have to let some jobs go. Somewhere there's a Big Mary who will do the job just for the money, so I send them to Big Mary.

And then there are many heads I have to pray over before I do them. They deserve a prayer. I look at those heads and I say, "Lord, I just want you to guide my hands," and once I do that, ideas start popping in my head. God leads the way and tells me what to do.

∞

Fantasy hairstyles like the hairstyle I'm wearing today

make me feel very theatrical, like a goddess, a queen.

TISCH SIMS

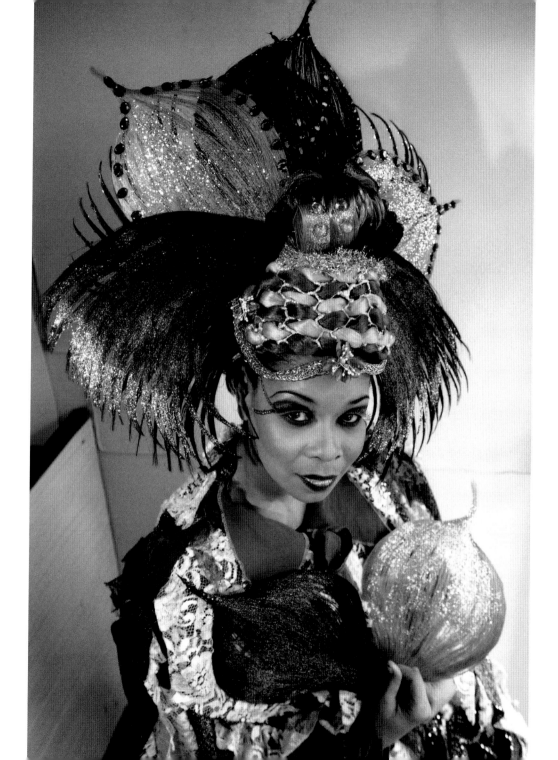

TISCH SIMS, 32

{Fashion Designer}

I WAS BORN AND REARED IN CHICAGO IN THE HENRY HORNER housing projects with my mother and two brothers. I was part of a huge extended family living in Horner with aunts, uncles, and cousins and I was always involved in activities at the Boys and Girls Club to keep me out of trouble. Living in the projects was a lot of fun and I learned a lot of things by being in poverty; I learned to appreciate the things I have today.

When I was growing up my mom kept my hair plain and simple, and my grandmother would straighten it with the straightening comb in the kitchen near the stove. The kitchen would get hot, so I'd sit there sweating, while at the same time getting my hair straightened. The problem was that as soon as your hair began to sweat it would kink up and you'd have to have it done all over again.

I was a very tender-headed child and I hated sitting in the chair to get my hair done. My grandmother would have to pop me with a comb to make me sit still because when you're tender-headed you're always yanking your head opposite of the way they want it to go. At the time, everyone had Jheri curls and finger waves, but my mother would never let me get that even though I wanted it.

Every summer in Chicago I went to summer camp. For camp I would get my hair braided because there would be no one there to do my hair. The whole summer my hair would grow out and with braids I could swim at camp

without a problem. When you're a child growing up in the projects, trips to summer camp are like trips out of town even though you may not have even left the city. It was a great experience and made me want to travel to see the world. I've traveled to Paris by myself.

In high school I was on the basketball team and I never did my hair. I was a tomboy and I didn't care about hair. I either had it braided to the back or wore it in a ponytail. I didn't start getting my hair relaxed until I was about to graduate. When I got into modeling I did a complete transformation. My high-tops turned into high heels and my jogging suits turned into dresses and skirts. Now I keep my hair long and straight all the time. I give a lot of consideration to my hair.

Fantasy hairstyles like the hairstyle I'm wearing today make me feel very theatrical, like a goddess, a queen. It would be great to get on stage in this. I like modeling fantasy styles in hair shows because you get a chance to see how you look in different styles. The styles may not be something that you would wear every day, but it's good to see what stylists can do to your hair. I feel like a different person when I wear a hairstyle and outfit like this. I feel completely out of the box.

People walk up to me on the street and say,

"I love your hair. What color is that?" I told one woman,

"It's God's color. I don't dye my hair."

TONYA LEWIS LEE

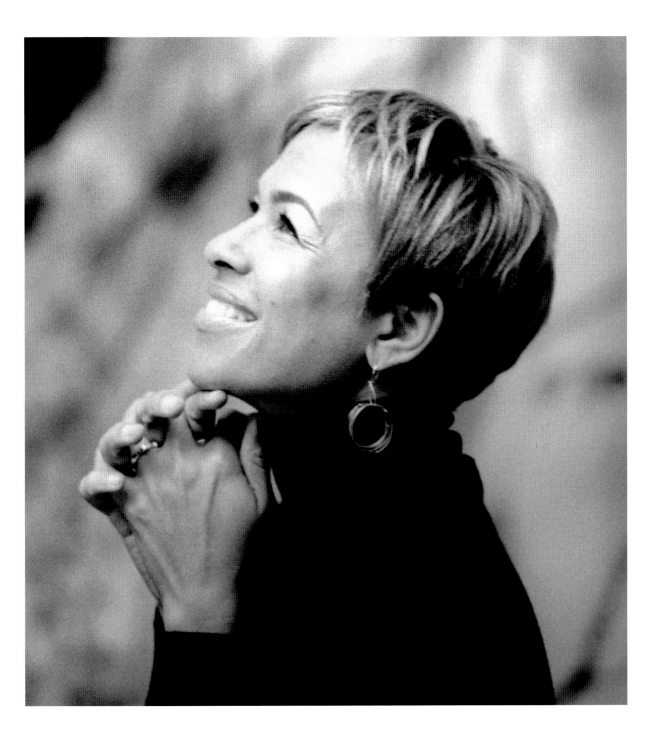

TONYA LEWIS LEE, 38

{Author and Television Producer}

WHEN I WAS BORN THE NURSE SAID TO MY MOTHER, "OH, YOU have a carrottop!" My mom said, "What do you mean a carrottop?" The nurse said, "She's a redhead!" My mom said that my hair was gold and she was certainly not expecting that. When you're pregnant you have visions of what you think your child will look like and my hair was not what she expected. At all.

Today you have so many people who dye their hair blond or my hair color, so people assume I dye my hair. And I think it says something about how they think I think of myself. It really frustrates me because the people who dye their hair just think it's fun and cute, but they didn't have to go through what I went through growing up feeling like a weirdo. People walk up to me on the street and say, "I love your hair. What color is that?" I told one woman, "It's God's color. I don't dye my hair." She said, "Oh. Okay." Totally not believing me! I've had comments like "Spike married somebody white." People think I'm from another country. And that kind of stuff drives me crazy because of my race politics.

I was recently at my parents' house with some other family members and my daughter, Satchel, looked around and said, "You and I are the only ones with the same hair color." Satchel has my hair.

Then the funny thing about my hair is that often when Black kids are born their hair is very straight and you always sort of expect it to "turn," as we say. And my mother grew up in a household with women who had straight black hair, but my mother had kinky hair. She was the only one, so no one ever really knew how to deal with her hair. My mother said that her grandmother used to

say to her, "Well, you had to either get the hair or the color. You got the color, I guess." You know how it has been with Black people with hair and skin color. My mother had grown up feeling like her hair was this horrible, hard, awful, coarse, kinky hair. So as I began to grow up the texture of my hair started to change. Now, my mother really didn't know how to deal with my kinky hair because her mother and grandmother really didn't know how to deal with her hair. They would press it, but they really didn't know how to *love* my mother's hair. And I say that because having had Satchel, I understand what that love is all about. Because I was determined to love Satchel's hair and I did. And that girl has got a head of hair on her head and it's so beautiful, and I do think it reflects the love that has been put into it and the patience.

Growing up I went through various phases with my hair. In the summertime she would rinse my hair with tea because it would get so blond from the sun. She would say, "Oh, it's getting so brassy." I always thought that that must have been a throwback from slavery. When I think about it as an adult now, it's so interesting that my mother wanted to get rid of that color. It just felt like some old slave thing that she didn't even realize, "Oh, you looking too much like massa. You gotta get that color back down." And what would the slaves use? They would use tea because they didn't have dye. I don't even know where she got that from; it was just ritualistic. "Girl, we gotta rinse your hair with tea."

Thinking back to when Satchel was born, I just cried. When the doctor handed her to me, I looked at her and she had gold hair like I had when I was born, and gray eyes. To have this little girl with hair like mine was such a gift to me. A little me. I thought, "I'm not alone anymore." When I look at her, it's a validation. It's a total bond and she's my girl.

∞

I wanted total natural beauty. That's what I was looking for.
My hair didn't grow to the length I wanted until I got locks.

∞

KIA DALYRIMPLE

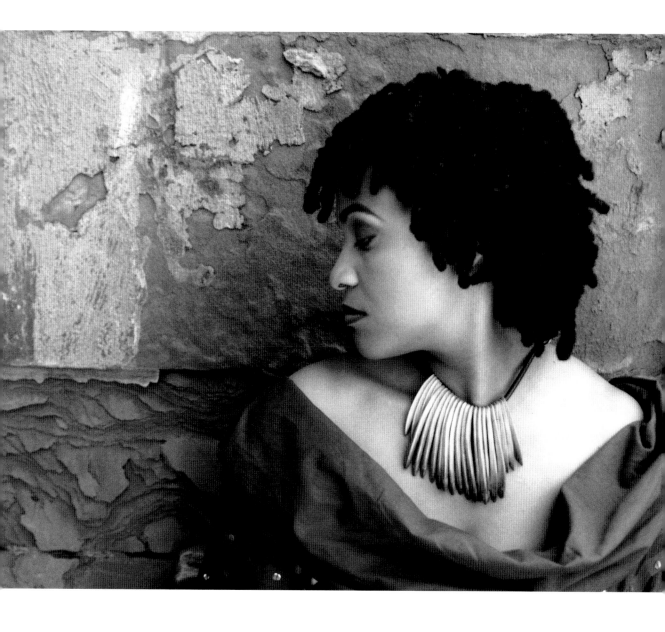

KIA DALYRIMPLE, 25

{Certified Fitness Trainer and Fitness Club Manager}

I THINK I WANTED TO HAVE LONG HAIR BECAUSE OF GROW-ing up with my mother, my grandmother, and my aunt. They always had nice, long, thick hair and that represented beauty to me. The women who had long hair in my family had a lot of class, they were very beautiful, and they always kept themselves well. It wasn't that I didn't feel beautiful, but I felt that I could look even more beautiful if I had long hair. Growing up seeing my mother, it was just her whole presence; her long hair brought out an aura around her that was warm, classy, and very stylish. If we went to the beach or to the pool, she would wash her hair and then it would naturally curl up. It was always long and beautiful. I always wanted to have that fresh, classy cool look that she always had. I always wanted long hair. My hair was maybe a little past my shoulders, but I always wanted it to be longer than that.

Between the ages of eight and twelve, I'd always wear T-shirts on my head that would flow all the way down my back, and that would represent my long hair. I would flip it around; it was fun to do that. I wouldn't say I was obsessed with having long hair, but I really wanted it. My mom got me a wig one time to play with. The wig went to the middle of my back just above my waist, and it was dark brown. I went a little bit crazy with it because I always wore it, but I wasn't allowed to wear the wig out of the house or the yard. I loved that wig, but eventually it began to annoy everyone. After a while I couldn't find the wig

anymore and as I got older I heard the story that my dad took it and burned it or threw it away. He was basically saying that you do not have to have this fake long hair and obsess over it when you have your own natural beauty. I was a little upset when the wig disappeared, but I got over it.

I was about sixteen or seventeen when I decided to lock my hair. There was a point in my life when I wasn't totally satisfied with my appearance. I knew I needed to do something to set myself apart from everyone else. The style I had, which was a perm and a short haircut, really wasn't fitting with how I was feeling inside. I didn't feel as confident as I should have been feeling. I wanted total natural beauty. That's what I was looking for. My hair didn't grow to the length I wanted until I got locks.

When I got locks it was a change for my family. Nobody really thought I would get locks. But my mother pretty much said, "Go for it," because she knew I had a sense of style, a sense of self. In the beginning my hair was short with twists. Some people accepted it. Some people didn't, like my grandmother who said, "What is that? That's horrible. Take that out of your hair." That's what she said at first, but years went by and now all I can hear is, "Kia, your hair is so beautiful."

When I see myself in an Afro I feel more powerful

than when I wear my hair permed and straight.

I feel like a Nubian sister, like I can take on the world.

THOUNDIA BICKHAM

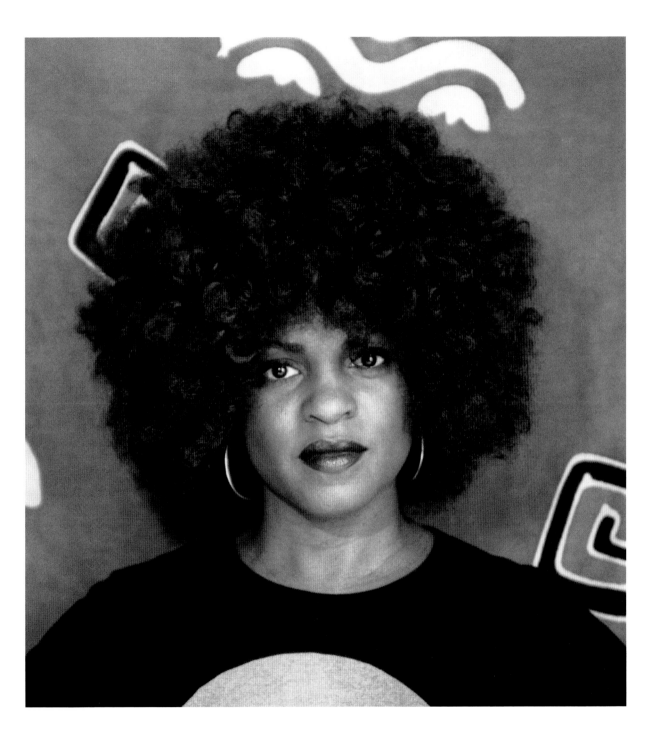

THOUNDIA BICKHAM, 44

{Actress}

MY NAME IS PRONOUNCED *Town-de-a*, BUT PEOPLE HAVE always called me Thunder. I grew up in Hammond, Louisiana, about forty miles north of New Orleans, and I have three brothers. Hammond's a small town and it was really a lot of fun growing up. I've lived in New York for seventeen years and have two sons, two granddaughters, and I'm having another son, but I've never been married. I'm sort of a free spirit.

When I was a girl I always had little braids. I was a tomboy, but my mother always put me in dresses and I could do anything the boys could do, but better. I could even wrestle the guys and beat some of them up. I would always beat up boys who picked on one of my brothers.

As a child I used to go to a lady named Miss Louise's house every two weeks on Friday to get my hair straightened. It was horrible. Miss Louise did hair on a back porch that she had converted into a salon. But when I was about thirteen or fourteen I started wearing an Afro and later I got a Jheri curl.

I have kinky thick hair. If I don't comb it, it will lock, but I don't see it as a negative thing at all. I recently had a kinky Afro, which is one of my favorite looks. When I see myself in an Afro I feel more powerful than when I wear my hair permed and straight. I feel like a Nubian sister, like I can take on the world. I think that power comes from the fact that the Afro is natural. When there are chemicals in my hair to make it straight, I feel weaker. I feel like I'm trying to be somewhat white, but I'm really just trying to control my hair.

I also get a lot of attention from Black men when I wear an Afro. Everyone calls me "sister" when I walk down the street. If you could follow me around with a camera you'd be amazed. I think the Afro symbolizes freedom to Blacks. I think they're saying to themselves that she's being Black and natural and I think they're happy to see someone who is comfortable with herself.

My mother, Lila Flowers, was seriously old school.

She was a glamour girl when she was younger

and very beautiful, and her hair was a part of that.

KATHRYN FLOWERS (LEFT)

Being twins Kathy and I wore our hair pretty much the same

growing up and our mother dressed us alike for

many years in elementary school.

JACQUELYN FLOWERS (RIGHT)

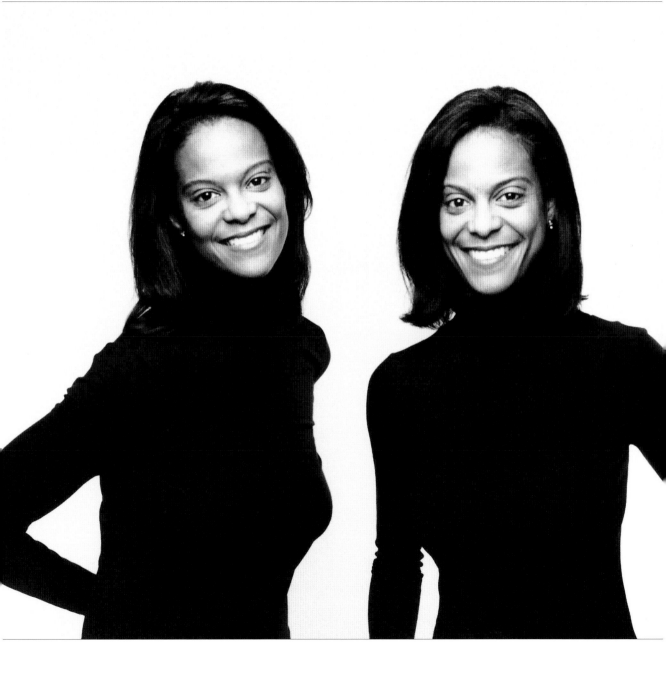

KATHRYN FLOWERS, 42

{Real Estate Agent}

I TRIED BRAIDS ONCE. I WAS GOING TO AFRICA FOR VACATION back in 1995 and people said, "She'll never do braids." Back then people associated braids with ethnic attire and braids were not very popular among my group of friends. I thought, "Oh, you don't think I'll get braids? I'm going to prove you wrong." I wanted locks in college and my mother almost had a heart attack. She said, "Over my dead body." I thought locks were cute. I grew up in a very structured household, but the other side of me is very bohemian. But I don't think I'll go back to braids. They were too much effort. I prefer the relaxed look; it's more convenient and gives you the freedom to switch up and do different things.

My mother, Lila Flowers, was seriously old school. She was a glamour girl when she was younger and very beautiful, and her hair was a part of that. She was big into how you looked and she wanted her girls to always look nice and their hair to look good and to be dressed a certain way and to wear a little makeup and, of course, I was never the one. Finally my mother said one day before she passed, "Do you ever wear your hair down, Kathy?" I said, "Mama, it's so much more convenient to pull it into a bun." But since then I've found myself thinking, "Let me go ahead and get my hair done because I know she would like that." I've probably worn it down more lately remembering how she felt so strongly about it. I can hear her saying, "Kathy, you'd look so nice with your hair done." She always loved it when I had it done, so every time I'd go home to Houston I'd try to get it done just to make her feel good. So now I find myself doing that a lot more in remembrance of her.

JACQUELYN FLOWERS, 42

{Municipal Government Official and Artist}

BEING TWINS KATHY AND I WORE OUR HAIR PRETTY MUCH THE same growing up and our mother dressed us alike for many years in elementary school. Later, while still in elementary school, that changed. We had the exact same wardrobe, but she allowed us to pick out what we wanted to wear and I think even early on we were trying to set our own identity.

I remember when Kathy got braids. She, a friend of mine, and I drove to Philadelphia from D.C. to have it done. I didn't care if I was going to Africa for three weeks or three months, I was not getting braids. I think your hair is a reflection of your personality and to some extent who you are. The way you dress, the way you wear your hair, and the way you behave, all those things are manifestations of your inner self. And I think that we're very unique individuals and can appreciate different styles in someone. But I do have a very strong sense of myself in terms of being more conservative and more classic in the way I dress and the way I wear my hair. But I have a great deal of respect for women who do things differently. That's what makes the world an interesting place. We're not all the same.

But overall, I am not obsessed with hair. I don't comb my hair and I don't brush it. I don't own a comb. I finger comb my hair. I throw my hair over a satin pillowcase at night and I take my fingers and I run my hand through my hair in the morning and whatever it looks like is what I go with.

Many African women think that having permed hair is beautiful

because they watch too much European television.

Harriett Indira Odei

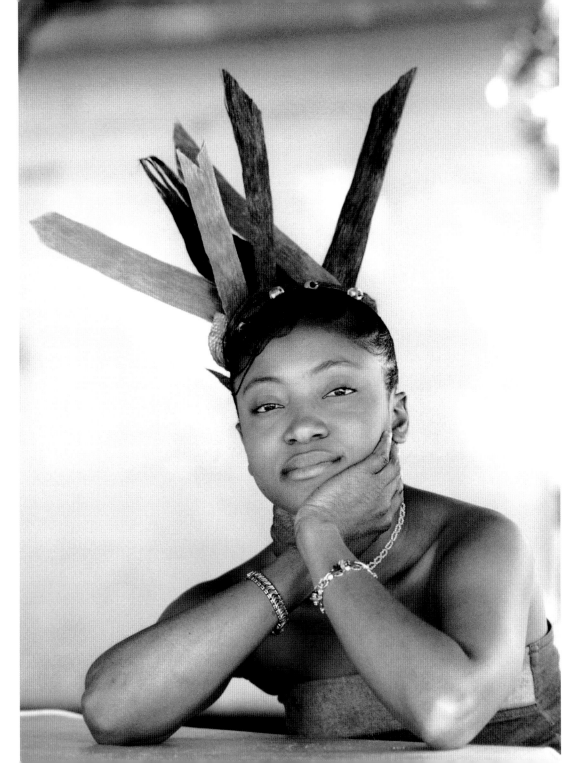

HARRIETT INDIRA ODEI, 24

{Administrative Secretary}

GROWING UP IN ACCRA, GHANA, THE SCHOOL I WENT TO WAS an Anglican school and they did not accept hair that was braided. You could not have traditional African hair because at that time they felt that braids would make you proud and that braids would distract you from your studies because you'd always think about your hair and how long it takes to braid it and things like that, so they made us cut it. I started wearing braids when I was thirteen years old. My first style, which my mother did for me, had tiny, tiny little balls done with thread all around my head. I don't know the name of it, but whenever you get your hair done for the first time, that's the way it is done.

When it comes to some Ghanian women wanting more Westernized hair, the fact is that things are changing. The world is going forward. In the city, women want to see more Westernized hair. But when you go to the villages the traditional hairstyles are still there and hairdressers in the city are now revisiting the traditional African styles. You see a lot of women with their hair braided instead of permed hair. They're trying to embrace the more traditional styles.

But many African women think that having permed hair is beautiful because they watch too much European television such as soap operas with white

stars. There are no Black stars. They see the white hair and they like it. I think that perming makes your hair flexible and you can shake it and it's beautiful. I think that is the reason many women like to perm their hair. But we have to learn to appreciate ourselves. We have to like what we have, use what we have. That is the best thing that will happen to Africans.

When you look at pictures from the 1960s in Africa, Black people were natural, they were braiding their hair. You did not see permed hair. But the world is now a global place, so things have changed. People travel and they see things that they like and they embrace them. In a way it's okay, but in a sense it's killing our culture. And in another sense permed hair is beautiful. But wanting to have something that is not from your origin changes you. It changes every part of you, your facial expressions, everything. It's killing our culture. We have to embrace our culture.

For my style today, my hairdresser is very creative and she wanted to give me something that would change my look. It makes me feel good. This style symbolizes purity to me. It's pure and it makes me stand out from the crowd. It's very unique. It's a traditional African style and it makes me feel special.

When people see my clients' hair I want them to say,

"Oh, Teresa did your hair." I haven't named the style I'm wearing today yet,

but one girl told me that it looks like a falcon.

Teresa Garbitt

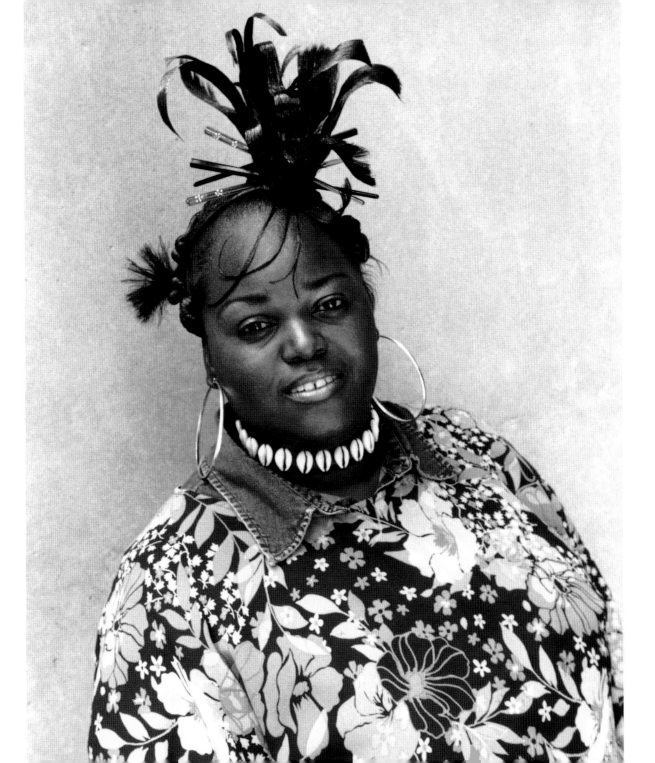

TERESA GARBITT, 32

{Hairstylist}

WHEN I WAS ABOUT ELEVEN OR TWELVE, GROWING UP IN NEW Jersey, I wanted to get a Jheri curl. I was so excited. I thought it was a good thing to have a bunch of curls. I thought it would be different. I already had a relaxer in my hair and I didn't realize you couldn't mix the relaxer chemicals with the Jheri curl chemicals. So when the lady at the salon put the Jheri curl in my hair, some of my hair fell out. I started crying and I called my mother to come to the salon and she said, "Well, there's nothing you can do now." When I got home, my mom fixed it up for me. They used to wear weaves back in the day, they weren't as big as they are now, but she added some hair to my head and it turned out to be kind of a bob look. Ever since then I've been into weaves. After I found out you could add hair to your own hair I've been doing all kinds of weaves, all different colors, everything. I really wanted to add hair to my head after that disaster. I'm lucky I didn't go completely bald.

My mom has supported me in everything. Even if I create a hairstyle and it doesn't come out good, she'll always have something good to say about it. She tells me to keep going and going. My mom is awesome. She's the bomb. If I could do half of what's she's accomplished in her life, I'd be satisfied. She

has her own business. She's my role model. You really need family encouragement when you're trying to do something with your life.

I knew that the Bronner Brothers hair show in Atlanta was coming up and the truth is that I only had ten dollars to spend on hair products to create a new style to wear to the show, and that's the style I'm wearing today. So I bought two bags of synthetic hair and a half pack of Yaki human hair. It all came to about $8.99, so it's really an $8.99 hairstyle. It only took me about ten minutes to create the style in my mind because I knew I didn't have much money to work with and I wanted to do something different. It took me about an hour to curl and twist it and I had to sit under the dryer for about a half hour. I got a lot of compliments. I wanted to see everyone's response to it plus do something different, something that you wouldn't see on a runway. When people see my clients' hair I want them to say, "Oh, Teresa did your hair." I haven't named the style I'm wearing today yet, but one girl told me that it looks like a falcon.

My big dream is to own a hair salon and also do platform work—to do hair for the big fashion shows for designers like Tommy Hilfiger and Calvin Klein. That's my dream.

I started to look around at the women I'm still enamoured of,

people I respect, and as I looked at them—this group of wonderful

Black women writers—Nikki Giovanni, Toni Morrison, Alice Walker,

they all have natural hair.

TINA ANDREWS

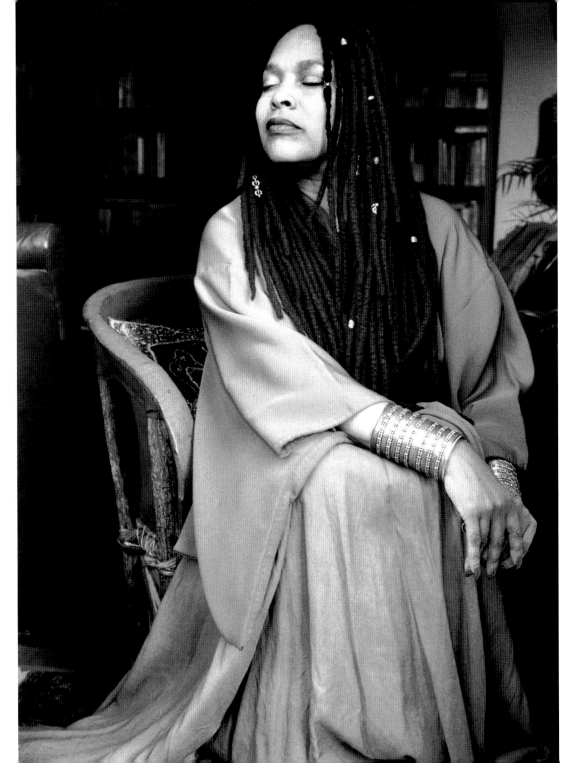

TINA ANDREWS, 46

{Writer/Producer}

GROWING UP IN CHICAGO I HAD LONG, RED HAIR, TRUTH BE told, and it had to be straightened. The worst thing was having my mom wash my hair then dry it and spend half an hour trying to get through what was called, in those days, "bad hair." And my father, God rest his soul, would constantly say, "Cherish your long hair. That's why I married your mom." So certainly in my immediate family, the long straightened hair thing was a big deal.

Many years later, Afros are in and now it's out of vogue to have straightened anything. "Black is beautiful!" I'm at New York University. Everybody's in an Afro. The standard of beauty is Angela Davis, Nikki Giovanni. Short Afros. Big blowout Afros. I had abandoned the whole middle-class, straight hair, bourgie look and had adopted this new "I am a proud Black woman" persona. Poet Nikki Giovanni spoke at Town Hall and I went to hear her. She's a small lady like I am. I looked at her and saw myself. She was the biggest influence on me as a young writer/artist.

The first time I went home from New York, stepped off the plane in Chicago and my mom and dad are standing there to greet me and looked past me like, "I don't know who that bugaboo . . . ," which is what I was called finally when they realized it was me. I can't describe the expressions on their faces. My mother turned around and walked away and I said, "Mommy?" She said, "I'm taking you home and I am getting a hot comb and I am pressing that hair. Perfectly good hair, how could you just ruin it like that?!" I heard it the entire drive home from O'Hare Airport. But that is when I first became comfortable with myself without makeup and with my hair not pressed.

I've worn locks for the past five years after having straightened my hair for many years. I was told that one of the reasons I was successful as a working writer in Hollywood was because I looked sort of like a Black Barbie doll. And I took offense at that. I didn't like being told that any part of my success had anything to do with anything as superficial as my hair. I remember washing my hair, twisting it, and letting it air-dry. When I untwisted it my husband, Stephen, who has locks, said to me, "If you don't believe that's true, what would happen if you went with that natural hairstyle?" But I can honestly say that I was challenged and part of my ego got into it because I said, "That can't possibly be true." I took my first meeting with a studio executive with my hair natural and the only comment was, "You changed your hair." It turns out that they weren't really keying in on my hair and I got the job.

The other thing that made me go natural was that I was lecturing a lot to Black women about putting their own ideas on paper and telling them that they could be anything they wanted to be. There was a part of me that did not feel genuine in lecturing to young women if I too was not going to present myself as a strong, proud Black woman with natural hair. I started to look around at the women I'm still enamored of, people I respect, and as I looked at them—this group of wonderful Black women writers—Nikki Giovanni, Toni Morrison, Alice Walker, they all have natural hair. The more you feel good about who you are and how you present yourself, the more it's reflected in your work. These days I actually don't care if you like my hair or not. Who knows, five years from now I may go bald. But I have the right to do that.

The old wives' tale is that the hairdresser's kids always

had the nappiest hair in town because we were always the last ones

to get our hair done because the paying customers had to go first.

Sandra Miller Jones

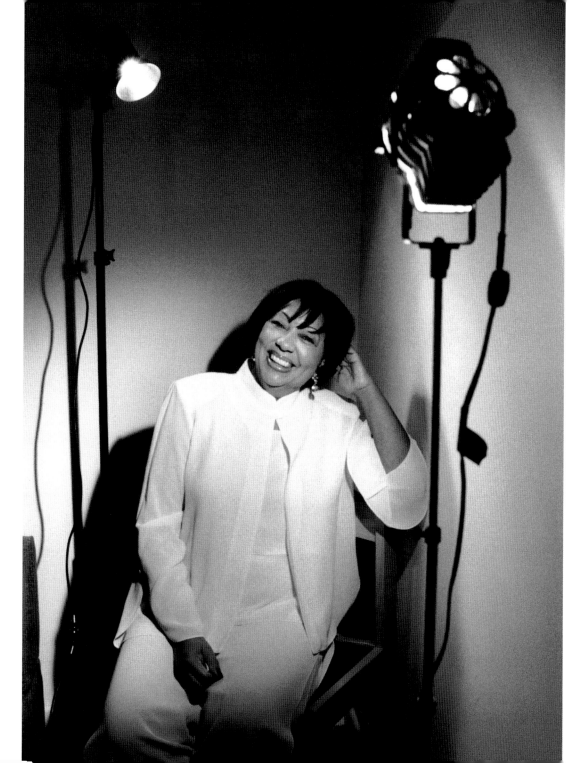

SANDRA MILLER JONES, 58

{Marketing Company Founder and Chairman}

I WAS BORN AND RAISED IN WINSTON-SALEM, NORTH CAROLINA, and hair has been a part of my life all my life because of my mother, who was a cosmetologist and a nurse, and was one of the first Black businesswomen in town. She had a beauty shop in downtown Winston-Salem in 1940. I had two sisters. My middle sister died when she was twenty-one, forty years ago. My father worked for the *Winston-Salem Journal and Sentinel*, which is now the *Winston-Salem Journal*. He started as a janitor at the paper and when the one Black reporter that the *Journal and Sentinel* had at the time moved to another city they said, "Robert's had a couple of years of college, why don't we just make him the reporter?" So he went from being a janitor one day, to being a journalist the next. That wasn't so different for us in terms of our lifestyle because my dad was always a very well-respected person in the Black community; he was always someone people came to for advice. His new job made it official that he was an opinion leader in the Black community. Daddy had a column that was called "Activities of the Colored People" when he assumed his new position. He changed it to "Around East Winston," because that's where many Blacks live. Black people would call the paper and ask to speak to "the editor," even though Daddy was just a reporter, and I just love each and every one of us for that.

My mother had a tremendous talent for getting people's hair to grow. She could make anybody's hair grow. One of the things she was always adamant about was making sure that the scalp stayed moist and that the hair stayed clean. By the time I was born in 1946, my mom had three girls and was doing hair in our basement. So I was right there with the business as I was growing up.

The old wives' tale is that the hairdresser's kids always had the nappiest hair in town because we were always the last ones to get our hair done because the paying customers had to go first. To this day, I'm not good at managing my own hair. I'm always looking to someone else to do it.

We had a very "normal" Southern upbringing. We were poor people, but we never knew we were poor because we had food and clothes and a good home life, a very stable one. I didn't know I was poor until I went to Howard University and saw all of these children who had lots of clothes, shoes, credit cards. I was amazed! But though we were poor, my parents taught us very basic values, including the need to work hard. That was one thing that was really impressed upon us, my mom being an entrepreneur and my dad being a hard worker. In addition to working at the newspaper, he had all kinds of secondary jobs to make sure that we had not all that we *wanted*, but all that we *needed*.

At Howard when I was a freshman and a sophomore in the 1960s, more than half the students were very anti the natural. They felt that it was very demeaning to African Americans, but by the time I was a senior, the homecoming queen had a natural. One of the things that changed attitudes about hair, of course, was being Black and being proud of that identity. James Brown's "I'm Black and I'm Proud" was one of the theme songs of my era. Stokely Carmichael was a student at Howard then, and I can remember him standing on the table in the cafeteria giving speeches. So as our attitudes about racial pride were being altered, our attitudes about the natural altered too.

In doing these dance pieces, I've learned that every man,

woman, and child has a hair story regardless of race.

Hair is a big part of how we define ourselves and other people

make assumptions about us based on our hair.

∞

JAWOLE WILLA JO ZOLLAR

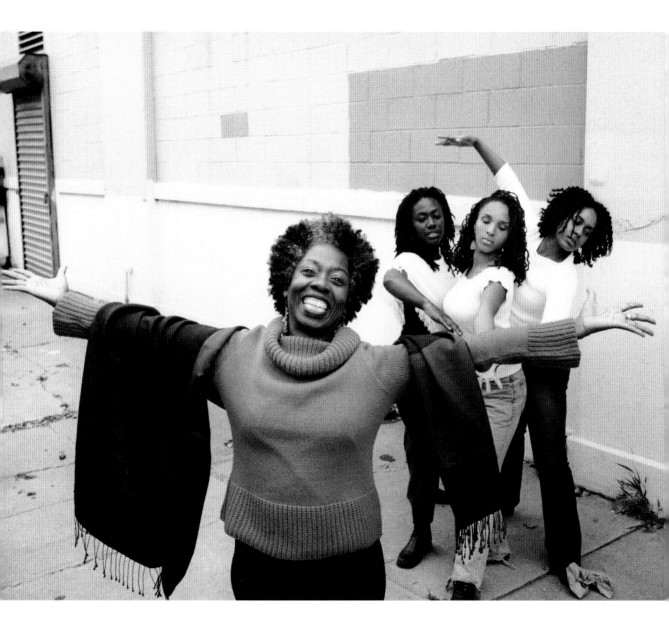

JAWOLE WILLA JO ZOLLAR, 53
{Founder and Executive Director, Urban Bush Women}

MY HAIR WAS ALWAYS KIND OF WILD AND UNMANAGEABLE. When I was growing up we straightened our hair, but whatever my hair looked like when I left the house, it never looked like that when I came back from school. So I earned the nickname "wild child." My hair would just be all over my head and I didn't care. And I didn't like getting my hair combed. I wish I'd known about locks back then because that would have been my choice.

I started Urban Bush Women in 1984 because I wanted a dance company that felt like musical groups like Sweet Honey and the Rock, and experimental jazz groups like David Murray and the Art Ensemble of Chicago. I wanted something that was an ensemble, an agreed-upon philosophical framework.

Over the years we've had women in Urban Bush Women with permed hair, but the women who have been most attracted to the troupe are women who are very independent in thought and who are searching for some type of authenticity within themselves, and that's what they're drawn to and they're most likely to have their hair natural.

Frequently on tour, we'd have locks, Afros, and other types of hairstyles and we'd always get comments from people about our hair, particularly when we were overseas. And we'd come back with a lot of hair stories. So I started thinking about it in terms of a performance work and how I could tell not only our stories, but stories that I'd heard from women across the country.

"Hair Stories" was our first round of performances and out of that it developed into "Hair Parties," which are all just different variations of "Hair Stories." In doing these dance pieces, I've learned that every man, woman, and

child has a hair story regardless of race. Hair is a big part of how we define our-
selves and other people make assumptions about us based on our hair.

At our "Hair Parties," an outgrowth of the research process for "Hair
Stories," I talked to men and women, but mostly women, about their hair issues.
And what I learned was that when we brought people together to talk about hair,
we always ended up talking about issues of race, class, and gender. But if I had
brought a group of people together and said we're going to talk about race, class,
and gender we would get, "Oh, God! Not that again." No one would want to
come. But doing it within the framework of hair, it leads to identity. Why is it
threatening for Black women to have natural hair in a corporate environment?

One of my favorite personal hair stories is about my great-aunt Ida Mae.
I hadn't seen her since I was a little girl and I had gone to my grandfather's
funeral. She was seeing me for the first time in many, many years and my
uncle Willie, her husband, said to me, "Wow, Willa Jo, you look just like your
mama. Oh, yeah, you got hair just like your mama," and my aunt Ida Mae
said, "Uh-uh, no, Dorothy had good hair." She later pulled me aside and
said, "Okay, you up there in New York and, baby, you having a hard time. I
really know how rough it is for you to try to be doing what you doing and you
trying to cut corners and save money, but, baby, you know, if you want me to
I'll pay to get your hair done." I said, "Aunt Ida Mae, I like it this way." She
said, "You like it?!" I said, "Yeah, I like it." She said, "Well, bless your heart."

I'm dark-skinned. I'm from Africa, and I have natural hair.

I want people to embrace our beauty.

∞

A B E N A

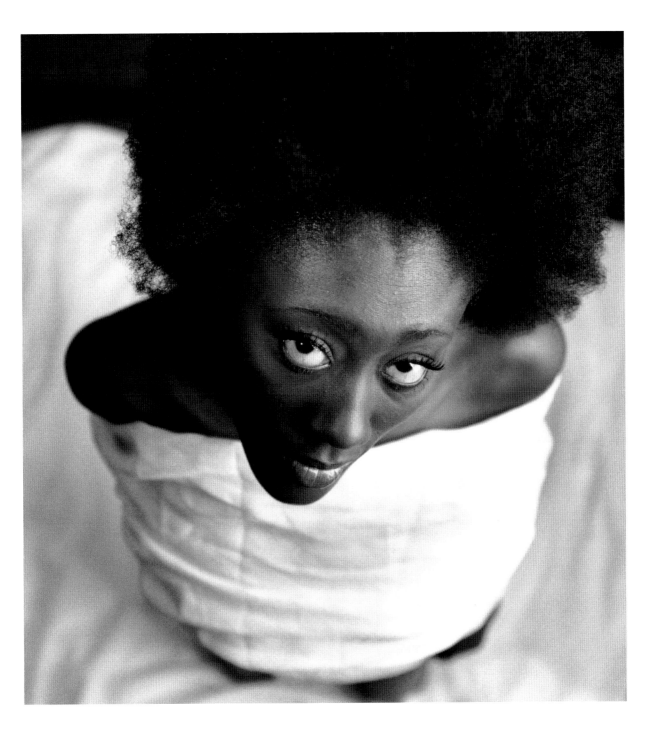

ABENA, 25

{Actress}

I WAS BORN INTO THE ASHANTI TRIBE IN GHANA, WEST AFRICA, into a rich tradition of chiefs. My name means "Girl Born on Tuesday." When I was four years old I moved to Newark, New Jersey, with my father after he fled Ghana following the coup when Jerry John Rawlings became president. My parents got divorced and my mother stayed in Ghana.

Living in Newark was like living in a little village. The building where we lived was half Ghanian and half African-American. In our house we spoke our traditional language, Twi, and ate traditional Ghanian foods like foo foo and plantains.

Because I lived with my father and did not know how to do my own hair well, people made fun of me because it was not as neat as everyone else's. I missed not having a mother to groom my hair, wash it, and to make sure that it was neat when I went to school.

My father didn't take me to the salon very much until I got older. Every time I went to the salon they'd put rollers all over my head and when they took the rollers out I'd have curls like an old lady. I never had the hip hairstyles like the Salt 'N Pepa hairdos—the short cut with one side long—like the other girls. I really wanted a hairstyle like that because I wanted to fit in with the other teenagers.

Now the Afro is my favorite hairdo. It's a symbol of freedom and liberation. When I decided to go natural I was in college at Rutgers University and going through an evolution. I needed change. I had a perm and everyone admired my hair because it was long and black and I took very good care of it.

When I went natural and cut off all of my hair, I'd never felt so beautiful in my entire life. At first some people said, "Are you crazy? You cut off all of that beautiful hair?" But those same people loved my twists. Walking down the street, men, women, and young kids, the way they would stare. Everyone loved it.

Being an artist feeds my soul. I want to break the stereotypes of beauty in America. I'm dark-skinned, I'm from Africa, and I have natural hair. I want people to embrace our beauty. It's not just light skin and long hair that is beautiful in our race. The slave mentality is embedded in us. Look at television and the videos. People are always trying to pigeonhole me as the "ethnic" girl. People have told me that I have everything that it takes to go far in my career; the only thing holding me back is my hair. They've told me that I should get a perm or get a long flowing weave.

What kills me is that ever since I was small, and especially when I went natural, people would say, "Wow, you're really beautiful for a dark-skinned girl." People in my own family would say that. Someone said to me, "Abena, let's be realistic. Dark-skinned girls are ugly. You are an exception to the rule." One of my father's wives once gave me a bar of bleaching soap and told me to use it because I was too dark. When I was a little girl people called me black spook, tar baby, blackie, African booty scratcher. None of that made me feel good.

I was disappointed because I felt my locks were keeping me from getting a job. So I wore a wig for my interview. . . . I thought, "Don't lose your job because of a hairdo."

❦

MONICA MALIKA JONES

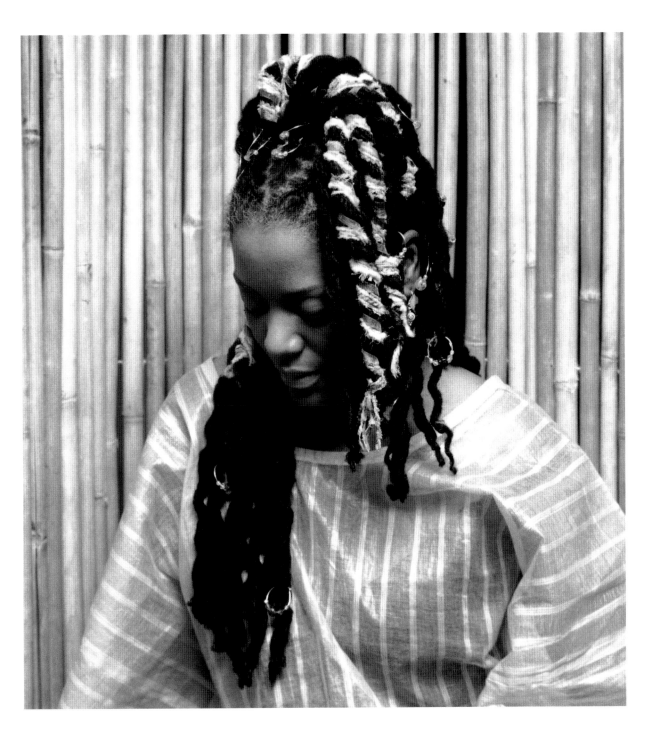

MONICA MALIKA JONES, 40

{Office Administrator}

I HAD A BEST FRIEND, EVA, WHO I GREW UP WITH IN HARLEM and I would let her do anything to my hair. Eva and I went from Afros together to the press and curl to Jheri curls. She even got me to go to the flattop. The funniest style for us was the Jheri curl, which we got when we were about thirteen. The directions said something about using curling rods. We only had French rollers. I told Eva, "What's the difference? A rod and a sponge roller." Well, there's a major difference, so I ended up with an Afro instead of a Jheri curl.

I wasn't a hair person because I had bad experiences at the salon. I was afraid of perms because they would burn your scalp. I recall going with Eva to get my hair done and I had to literally tell the stylist, "Listen, the perm is hot. Rinse it out." And she ignored me and I finally just demanded, "Get it out!" like Denzel Washington in *Malcolm X* when he had to put his head in the commode.

I decided to get locks when I had a car accident and hurt my arm. I realized that I couldn't twirl the curling iron. So I thought, "Mmm, now what do I do?" Plus, I was in Trinidad for a couple of weeks and the power kept going out, so most times I was there with an Afro. After Trinidad, I came and went natural. That was 1992. I have been growing locks ever since.

When I went to my present job, five years ago, my hair was already locked so that wasn't a problem. But the interviewing process for this job was really a trip because I had a headhunter who said, "Maybe you should pull your hair back and wear some pearl earrings, and not move too much so they don't

know how much is back there." I was disappointed because I felt my locks were keeping me from getting a job. So I wore a wig for my interview.

Before my present job I worked at a financial services company and wore a wig my whole first year. I thought, "Don't lose your job beause of a hairdo." I would go to Lee Priestly and get my locks done, but when I went to work I would throw on this nice Cleopatra full-length wig. The wig changed my whole life. It was fabulous. Old women would come up to me and ask, "Where did you buy that?" I thought, "Dag, how do they know?" But I didn't want to lose my job over locks. Locks are not always neat in their initial stages. You've got the "Buckwheat" style, etc. I just thought that if I'm going to do this, I'm going to do what I feel is the right way to make the transition. But there were days when my friends would say, "Look, you're gonna have to take that wig off. Your dreads are coming out the back."

I ended up having to file discrimination charges at the company. This guy found out about my locks and it was during the South African elections in 1994. He said to me, "What's up with your people?" I said, "Excuse me?" He said, "I hear you got nasty dreads underneath that wig." It became an issue. And I said, "Before we take it any further, you need to just hush. You're out of place." I ended up having to bring him up on charges because the comments he made were out of line. It was strictly about my hair. The case went to human resources and he was reprimanded for it. Later, one of the attorneys at the office approached me and said, "Look, I really have no Black friends, but I really need to ask you, we work together, I really don't know you. I'm going to be honest. They're saying lots of things. What do you do with your hair?" He was more open about asking me honest questions about my hair than being ignorant and spreading rumors. I was okay with that. I haven't had any problems since then.

<center>∞</center>

Believe it or not, I didn't hear the term "good hair" until I went to college at Howard in the late 1970s. In Newark, in the 1960s and early '70s, talking about "good hair" was a political no-no.

∞

BENILDE LITTLE

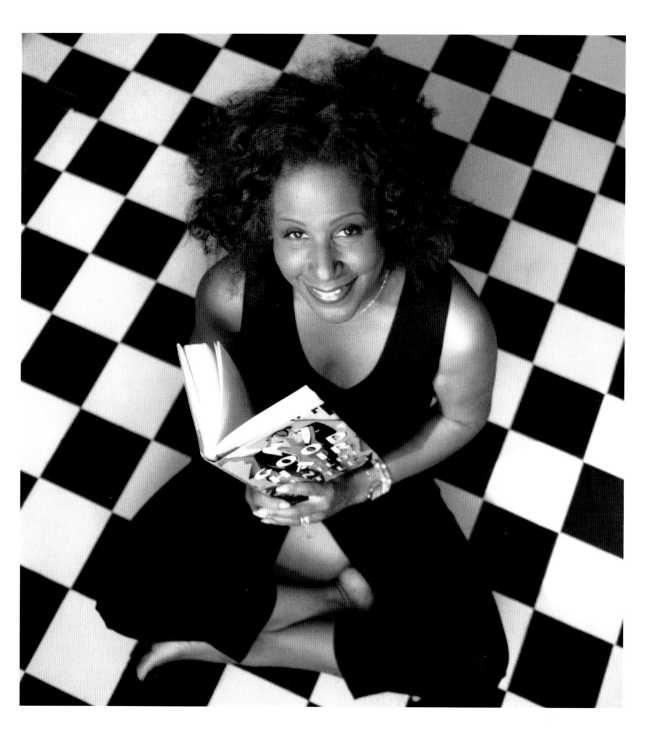

BENILDE LITTLE, 46

{Author of Four Novels}

MY FAVORITE HAIRSTYLES ARE WILD DIANA ROSS, CHAKA KHAN hair. I think it's sexy, I think it's free. I think sexy is free. I just love it. I just like what's more indigenous. To me, that's most attractive. Working with what you're given. I just think your hair looks better natural, the way it is supposed to be.

I came of age in Newark, New Jersey, in the late 1960s and the '70s and one of the big influences for me in terms of hair politics was that it was a really heady time. It was the Black Arts movement. Everything was political. I was a little kid, but I had older brothers who were in high school who would go see Amiri Baraka, who used to have these weekly sessions in Newark, and I was influenced by what they said was right. I remember my mother used to straighten my hair with a hot comb and my brothers started complaining about it. They'd say that it was a slave notion, a holdover, this whole idea that your hair had to be straight.

I had my first Afro in the sixth grade when I stopped letting my mother press my hair. I had my first Black teacher then too, Mr. Wilson, who was youngish and very theatrical and he loved my new style. He made a big deal about my hair. There was affirmation from all sides, which I think is a big problem today. Our kids are not getting that now—their looks, their culture, anything. In Newark I was surrounded by Black people who felt good about being Black. That was a blessing.

When Newark started changing and we had the riots, and all of the people who could move did, my parents didn't. They said, "We're not moving. Black people are moving in and we don't need to run from them." But lots of

Blacks did run and all of the whites left. Literally, overnight my neighborhood went to Black from white. We were the first Black family on the block in 1950 and by 1967, when the riots happened, everything changed overnight. I was young so I didn't understand the nuances of what was happening, I didn't get the whole Black/white thing. By the time I looked up and started paying attention to race, which is when I was about ten years old, white people were ancillary. They really weren't a part of my daily life. I'm struggling now because I have a child growing up in a very integrated environment where she is about 20 percent of the population, or 30 percent on a good day, and I'm having a hard time helping her navigate because I didn't grow up with the person in front of me flipping her hair in my face.

Believe it or not, I didn't hear the term "good hair" until I went to college at Howard in the late 1970s. In Newark, in the 1960s and early '70s, talking about "good hair" was a political no-no. People may have thought about it, but didn't say it.

When I got to Howard, I initially experienced culture shock. I thought it was going to be an extension of where I grew up—everybody was Black, blah, blah, blah. Everybody *was* Black, but everybody was very, very different. And I didn't know about all of this class strata and color and hair drama. The economic disparities were very, very slight in Newark, but at Howard you had people who were fifth-generation college, the whole thing.

When I decided to write a book I knew I wanted to write about class differences and I thought the title *Good Hair and Other Plantation Luggage* seemed appropriate, I later shortened it to *Good Hair.* Class, color, and hair issues are here with us to stay and that's really sad. I don't think people are open to being reprogrammed.

∞

Going natural for the first time was wonderful.

I felt I was making my own statement.

I had already done what everybody else wanted me to do.

Virginia Flintall

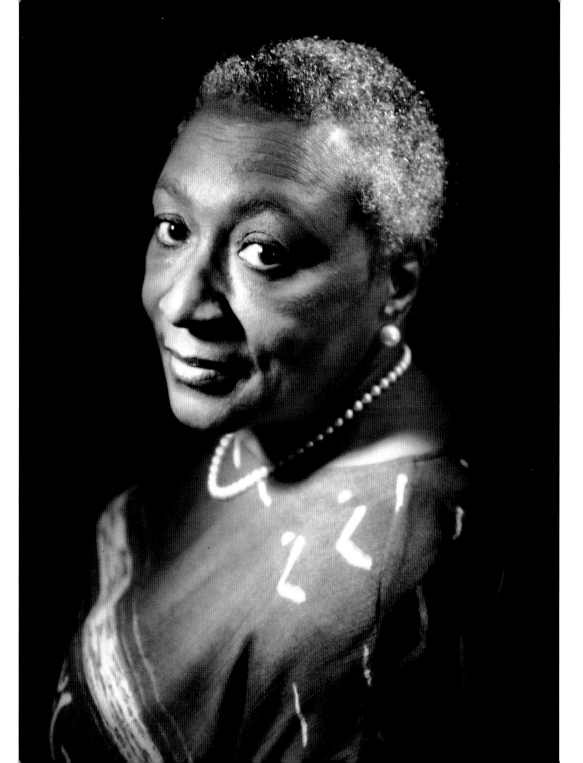

VIRGINIA FLINTALL, 60

{Psychologist}

I REMEMBER GOING TO A SALON IN HARLEM AS A CHILD desperate to have my hair done, because it had to be straight. The hairdresser washed and straightened it with the hot comb and I had really long thick hair and I remember the hairdresser ripping open my scalp and having that hot, hot comb burn my scalp. But you didn't dare complain because then they wouldn't straighten your hair and then you wouldn't be pretty.

Over the years the salon has been a place for Black women to gather and socialize, talk, and gossip. Now salons also serve the function of giving us a place to come and relax and enjoy being pampered and enjoy being beautiful.

I decided to go natural in the sixties. I wanted to do it in '63 or '64, but I was finishing college at North Carolina College for Colored People at Durham in '66—now North Carolina Central University—and I was getting married and my mother made me promise that I wouldn't do that to her—walk down the aisle with a 'fro. My mother was not having me in a 'fro. She was about sick of me anyway because I started my college career in New York at Long Island University and I wanted to get involved in the Freedom Rides and she forbade me, so the next year I transferred to North Carolina College, where I could go to jail and sit in at lunch counters. It got to the point where

I could no longer be nonviolent, so I decided that I needed to do some other stuff like voter registration because the next white so-and-so who put his hands on me was going to be a dead one.

We felt empowered after we crushed the South and opened up restaurants we couldn't eat in previously and I just felt that power. I wanted to say to white America, "Look out." So as soon as my wedding was over I went natural. I had a huge, seventies kind of 'fro. Going natural for the first time was wonderful. I felt like I was making my own statement. I had already done what everybody else wanted me to do. Why have my hair looking like the white man's hair after having faced those white students from Duke University who didn't want us there and who threw milkshakes at us and only to have the stuff bake on us in the sun? I eventually did go back to straightening my hair, but then about fifteen years ago I went back natural. Wearing it natural is very freeing, and I've never dyed it. I enjoy being gray and I've earned every one of them.

We have such an array of hair choices today. Some people prefer to have their hair straightened, some have extensions, some buy hair or whatever, but we've worked hard to have those options.

*My grandma likes my hair to be in curls and when I have curls
she'll say, "I want you to keep your hair just like that."
I'll say, "All right, Grandma, all right."*

∞

DARIA CUNNINGHAM

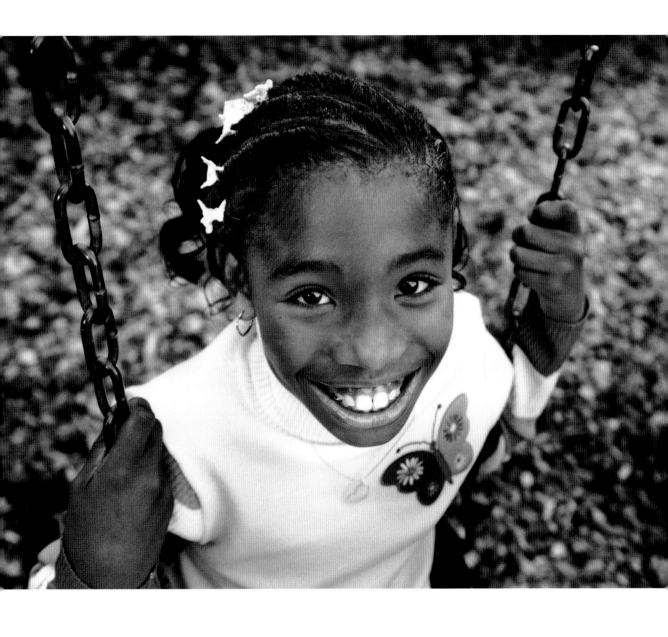

DARIA CUNNINGHAM, 10

{Elementary School Student}

I LIVE IN BOWIE, MARYLAND, AND I AM AN ONLY CHILD. My dad is the pastor of Hear the Word Bible Church and I sing in the choir.

My mother fixes my hair all the time and I like getting my hair done, but sometimes it hurts when she combs it out because my hair gets tangled. I got my thick hair from my dad's side of the family. When it gets tangled up, my mom, she really digs in it and I move my head around and she has to tell me to sit still. It hurts. Sometimes when I don't want to get my hair done, I run from my mom and she has to chase me to make me sit down.

I also sometimes get my hair done in a salon, but it doesn't feel like home to me there. At the salon the women talk a lot. They say things like, "Girrrl, on Saturday I'm gonna go shopping and I'm gonna do my thing!" They're funny. My stylist is Dawn and she gives me a perm and it burns and I scream loud in the salon, but afterward I look pretty.

One time I was in my mom's friend Denise's wedding. I was a junior bridesmaid and I had to walk down the aisle with a boy. I was so excited about being in the wedding, but I had butterflies in my stomach because people were staring at me when I walked down the aisle. My hair looked beautiful. My mom washed my hair and then she rolled it and put curls in it. People came up to me and said, "I really like your hair. Who did it?" I said, "My mom did." That made me feel great. I felt like a doll. A lot of people liked my hair that day and I felt special.

I spend every Sunday with my grandma. We talk about cooking and shopping and I help her cook things like macaroni and cheese. And she tells me that she wants me to do well in school. She says stuff like, "If you do bad in school, I'm gonna whip your tail." She's a tough grandmother, but she's nice. My grandmother collects dolls and she gave me a Black doll, a white doll, and a Hispanic doll and they all have different types of hair. The Black girl has kinky hair and the white and the Hispanic dolls have curly hair. I keep my dolls on my shelf in my bedroom.

My grandmother wears her permed hair out and sometimes I wear braids in my hair. I like braids, but my grandmother, she doesn't like braids. One time she said to me, "Why do you get braids in your hair all the time?" I said, "I don't know, Grandma." She said, "Stop getting braids!" I don't know why she doesn't like braids. My grandma likes my hair to be in curls and when I have curls she'll say, "I want you to keep your hair just like that." I'll say, "All right, Grandma, all right." Then she'll say something to my mom about my braids, but my mom will just tell her, "Don't worry about her hair." Grandmothers can be old-fashioned sometimes.

I'm so lucky with my skin color.

For a light person this color would clash. I can wear any hair color.

Carol Andrews

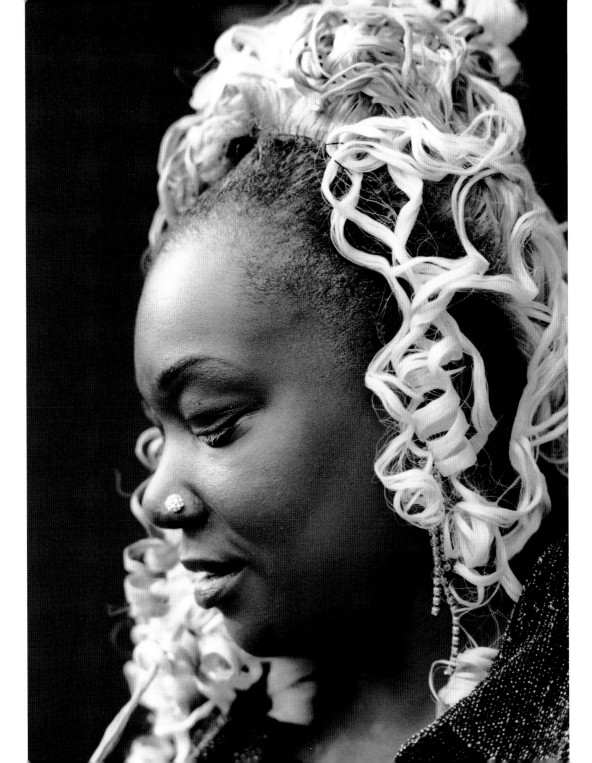

CAROL ANDREWS, 44

{Hairdresser and Fitness Instructor}

I WAS BORN IN GUYANA, SOUTH AMERICA, AND MOVED TO London when I was a little child and still live there. I'm the firstborn. There are seven of us and I had to do my six sisters' hair every weekend. That's how I got into hairdressing at the age of ten. I did all of the hair in the family. My mother knew I was going to go into hairdressing.

I experiment with a lot of colors with my hair and also my clients'. If you have a very good imagination, you can do so much. I like the brightness of the style that I'm wearing today. The brighter it is the better. That's my personality. I'm a bright, bubbly, outgoing, outrageous person. If anybody saw me in a dull color, they'd say, "That's not you." I like blond and beige too. Blond is very good for my skin color and complexion. Because I'm dark-skinned, it brings me out. I get people staring at me and they're always saying, "Goldilocks, Goldilocks!" Everyone's always staring at me. Or I get, "Hey, Blondie!" I said to a guy in Brooklyn, where I'm visiting, "Well, that's my name. If you want to call me Blondie, it's up to you." That's exactly what I said to him. He said, "It looks good on you because you're dark." He was just flirting. Women say to me, "Carol, I must admit. It does suit you." I'm so lucky

with my skin color. For a light person this color would clash. I can wear any hair color. I've got ten wigs at home and weaves. They're all different, different, different, different colors. I have red, I have blue, I have orange, I have lime, purple, and I've got a rusty color. As soon as I go back to London, I'm going to take this blond and beige out and wear a different color. I usually wear a different color every day.

I've won a number of beauty contests too. I've been Miss Big and Beautiful and Miss Planet Big Girl. I'm in pageants all the time because I like the catwalk. I just like the excitement of people staring at me. It takes a lot of confidence.

I've learned that the key to anything is success and progression. You must be positive about what you do. I've been brought up to do what I have to do. Get up and get. Get up and get. Both of my parents would say, "Girl, in life, if you want anything, you gotta go out there and get it." Their saying in Guyanese is that you have to "Get up and get. If you don't get up and get, the dog will eat your food."

Now I don't really care what other people think.

Losing my hair has forced me to let go and face fear head-on.

SHEILA BRIDGES

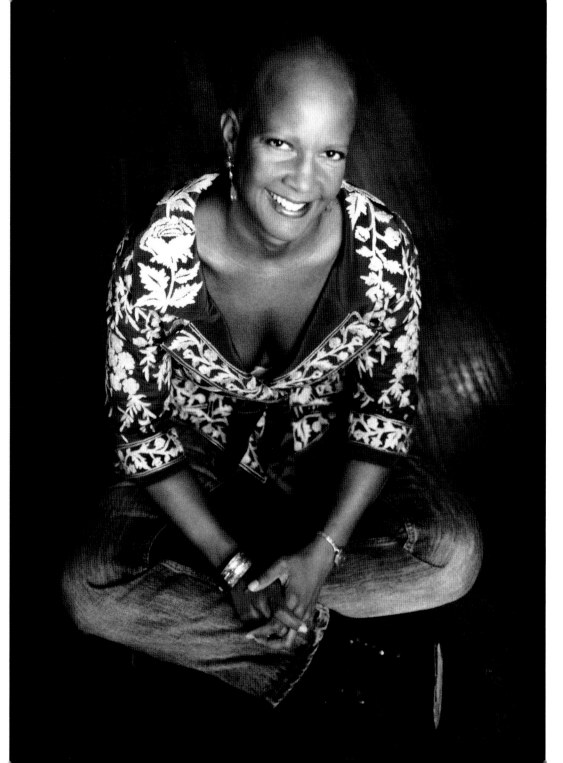

SHEILA BRIDGES, 40

{Interior Designer, Author, and Television Host}

I ALWAYS LIKED MY HAIR. I HAD BIG, CURLY, SORT OF UN-ruly, wild hair. The most distinguishing thing about my hair was the color. I had light brown, blondish hair. That was always something I got comments about.

About a year ago I noticed that my hair looked thin. I also had two tiny bald spots about the size of a nickel at the back of my head. I asked my hair-dresser about it, but he hadn't noticed anything unusual. A couple of weeks later I was diagnosed with an autoimmune disease called alopecia areata, which causes hair loss on the scalp and on the body. I started treatments, and for a while I was able to hide it. I'd lose a patch of hair, then it would grow in, then a patch would come out somewhere else. Within two months, my hair loss ac-celerated; every day I'd have handfuls of hair in my hands when I took a shower. Suddenly, as a person who never cared much about hair, I became completely hair-focused. Every hair on my head counted and took on a new level of significance. I felt helpless. There was nothing I could do. I like to be in control, so it was difficult to face something that I had absolutely no con-trol over. One day I literally couldn't leave the house. I had lost so much hair that I had just a patch hanging over my forehead. Everything else had fallen out, including my eyebrows. I was in the middle of the season for my TV show, still doing segments on NBC, and had my regular business and personal commitments, but life was supposed to go on even though I was completely ill-equipped. I had nothing. No hair, no wigs.

I suddenly became envious of people whom I wouldn't ordinarily envy. At the grocery store I'd see the cashier and think, "Wow! What I would give to have her hair." I developed a heightened sensitivity to hair.

For my fortieth birthday, my brother took me out to dinner and I asked him to bring his clippers so I could shave off the little bit of hair I had left. That was the most empowering moment because I finally accepted what was happening and realized how much energy we put into how we feel about our hair.

For the most part, I feel fine. What's hard is reconciling my personal and my professional lives because I prefer not to wear a wig. When I put on a wig I feel like I'm wearing a hot, scratchy wool sweater. I always feel like the guy with the bad toupee. I've had all sorts of funny things happen since I lost my hair. In L.A. while taping a show with the host of *Entertainment Tonight* the air-conditioning stopped working in the limo and the driver had the bright idea to open all the windows and the sunroof. My wig was blowing every which way but out the sunroof and I kept trying to hold it down. When I got out of the hot limo my eyebrows, which had been drawn on with makeup, had melted and expanded. I looked like Groucho Marx.

Forty has given me a different perspective. Now I don't really care what other people think. Losing my hair has forced me to let go and face fear head-on. It's a big order to fill emotionally because when you're bald everyone feels they have the right to say what they want to you. A lot of boundaries are crossed. Women tell me that they would never be able to leave the house bald, and that tells you about the power we give certain things. But once you let go, you let go. Now I know that what you see is what you get, and that you make the best of whatever you have in life, whatever that is.

I set my hair money aside like it's a bill,

if you want to know the truth. It's like paying the phone bill,

the electricity bill, the gas bill. I don't play about my hair.

∞

NITIYA BARRY

JOANNE SMITH (LEFT), NITIYA BARRY (CENTER),

KASHUNA BUTLER (RIGHT)

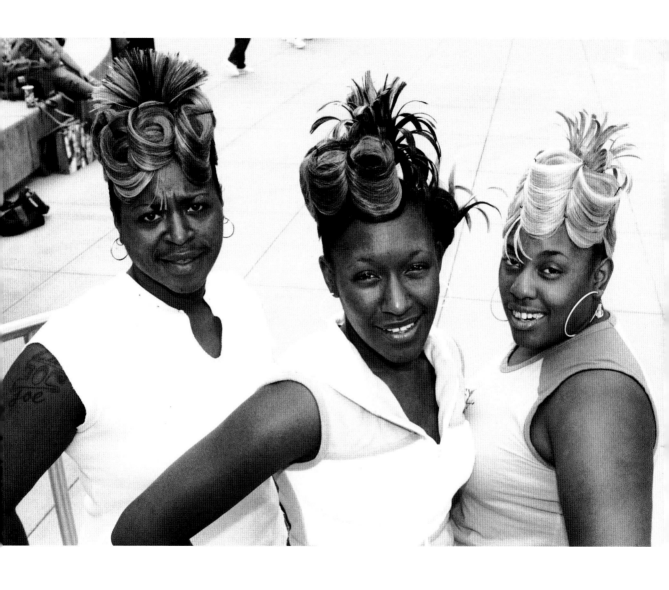

NITIYA BARRY, 23

{Store Cashier}

I HAVE TO GET MY HAIR DID EVERY WEEK. IT'S A MUST. Either every Thursday or every Saturday I get my hair did. If I don't get it did, something's wrong. I set my hair money aside like it's a bill, if you want to know the truth. It's like paying the phone bill, the electricity bill, the gas bill. I don't play about my hair. If I don't buy myself nothing else, I get my hair did every week. It's that serious for me. Your hair is your appearance.

When I was young my mom would take me to a hair salon called Janice's House of Glamour here in Columbus, Mississippi, and they would do my hair in these really tight curls. From the time I was nine to thirteen my mother made me go to the salon with her to get my hair done and I never did like it. I hated it. Every time I went there I was thinking, "Why my mama do me like this?" But we never talked about it because she thought I liked it, so I wanted to let it stay that way. I didn't want to hurt her feelings because I was the only young girl in elementary school to get my hair did every week. Everybody else, they mama did they hair.

The children at school told me they liked my hair, but I think they were just trying to make fun of me. At school I didn't feel too hot about my hair, but I knew my mama would have whupped me if I messed it up. She didn't play that. But I never said anything to my mother about my hair.

When I turned sixteen I started going to my own hairdresser. I was a big girl then, I was a teenager. The first style I chose was a plain little bob. It was the style at the time. When I got that bob I felt so pretty. The girls loved my hair. It was one of my favorite hairstyles as a teenager.

A few years ago, I was in my cousin's wedding and the hairdresser messed up my hair, but it was too late for her to redo it because I had to go to the wedding. I was so mad. My hair was supposed to be in a French roll with some banana peel curls in the front of it. I don't know what kind of French roll it was because it was so loose. When the rain hit it, it fell. That's how bad the hairstyle was. I cried at the wedding. You would have thought it was my wedding because I was crying just that hard about my hair. I cried because I knew my hair was messed up and I had been planning for this wedding for so long. That was the first wedding I was ever in and I was very excited. I was thinking, "I get to be in a wedding and I get to walk down the aisle and maybe I'll catch the bouquet." The dresses were beautiful, but your hair is your appearance and my hair was messed up.

People probably thought I was crying tears of joy, but I was so mad. One girl had the nerve to tell me that my hair looked pretty and she knew it was ugly. I was ready to fight her. I was ready to fight her. I was. She was insulting me. She knew it wasn't pretty. I really gave her a mean look. My family said, "You need to go get your money back." It was my first time going to this hairdresser and I was just trying her out. My family said, "I don't know why you tried her out for a wedding anyway." I left after the ceremony. I wasn't in any of the photos. I didn't even go to the reception.

My hair spoiled my whole day. I got home and washed my hair and curled it. I take my hair very seriously. Your hair is your appearance.

∞

Getting a perm in Ghana makes a statement to people
that you are an adult. On the other hand,
when you cut your hair it makes you look young.
To me, a perm makes us beautiful.

Naomi Kimberly Lomo

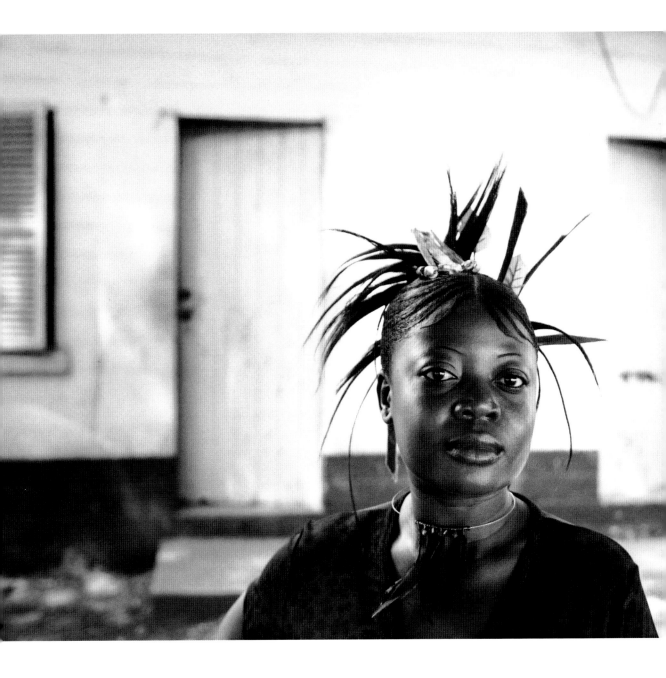

NAOMI KIMBERLY LOMO, 24
{Business Student}

I GREW UP IN THE GREATER ACCRA REGION OF GHANA, WHICH is a very nice place to live. I'm an only child. My mother has her own business. She imports lace from Nigeria. My father died twelve years ago. He was in the shipping business.

Ghana is a special place because we have peace. We have freedom and justice here. You can do whatever you want to do. You can move about, but in some countries you do not have that freedom. But in Ghana we are free.

As a little girl in Ghana I always wore my hair cut short. I went to a government school so there were requirements for hair and I wore it short until I was eighteen. At eighteen, when I completed our equivalent of a U.S. high school, I started going to the salon. I was very excited, but because my hair was short, there was no real style to it even though it was permed. But it still made me feel like an adult. I got a perm because I wanted to look like a mature person. Getting a perm in Ghana makes a statement to people that you are an adult. On the other hand, when you cut your hair it makes you look young. To me, a perm makes us beautiful. When I got a perm for the first time, I got lots of compliments. You can do different styles with hair that is permed. I do not like natural hair. My mom also wears permed hair.

For special occasions in Accra I like to wear my hair wrapped. Normally, wrapped hair is permed and they use hair pins and styling gel to wrap the hair around your head. If you have short hair, they attach synthetic hair to the permed hair before wrapping it so that the hair looks neat and beautiful. Three years ago my auntie got married and I wore my hair wrapped. It looked nice. It was a very big wedding with over five hundred people and we had lots of good food like rice, fish, and meat. Everyone kept asking me who did my hair. It was beautiful.

The style I am wearing today is called Magara. However, the hairstyle on women that I admire the most is dreadlocks. I love movies and I watch a lot of Nigerian films and in the films some of the ladies have dreadlocks and I like them. I would like to get dreadlocks one day

Growing up in Ghana my parents shared traditional African proverbs with me. The proverb that best states how I see life is "Charity begins at home. Show me your friend and I will show you your character."

When I came back to the salon after my husband died,

it was like a comfort zone for me.

I didn't realize how much the people who worked for him

really loved him.

B UNNY P LASKETT

(with son Joseph Plaskett Jr.)

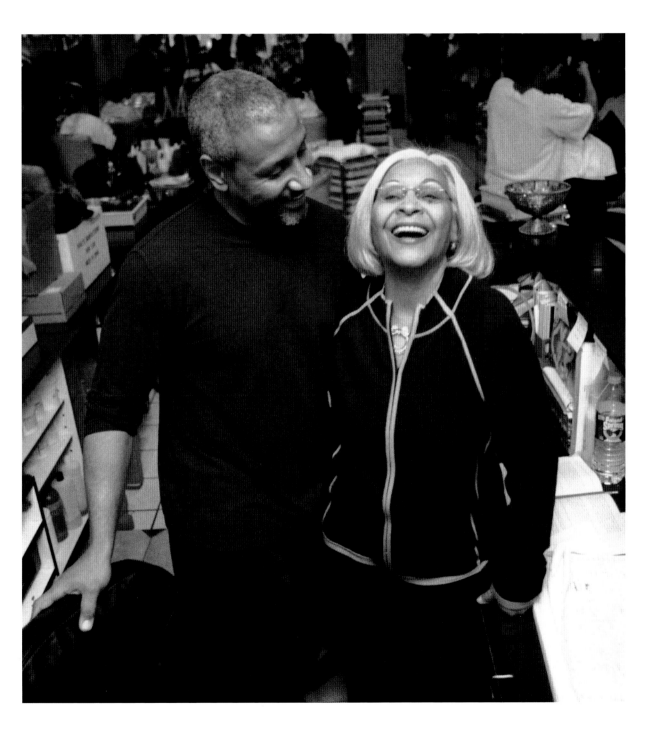

BUNNY PLASKETT, 74

{Salon Owner}

I THINK BEAUTY IS VERY IMPORTANT. YOU ALWAYS WANT TO look your best, and if you have your hair done and your makeup on, you'll look good. You can have on the most expensive dress, but if your hair's not looking good, you won't look good or feel good.

My late husband, Joe, first opened a hair salon forty years ago in the East Village of Manhattan down on Avenue A, after having first invested in another hair salon. I told him that he should learn more about the business in case he ever needed to step in to run it.

Joe cared about women and how they looked. If his stylists did a job that he didn't think was good, he would require the stylist to do it over. Some thought that was harsh, but he thought that when you walk out of the salon you represent the shop. He was more into pleasing the customer than making the stylist look good. Service is important to us at Hair Styling by Joseph.

Most of our customers have been coming here for years. People like to come to the salon because we have a lot of fun. On Saturdays at noon we serve pizza to the customers. Some stay for three or four hours and even stay and talk for two hours after their hair's done. The shop is very social. The house-wives talk about soap operas, the businesswomen talk about the theater, the vacations they plan to take, and the stock market. And we've always had a lot of cute guys working here. They're all married now, but most of them met

their wives here. We've also had a number of celebrity clients over the years like Diana Ross, Nancy Wilson, and Patti LaBelle.

When young people would come to our shop, after they had come for a couple of months or so, they would kind of look at us as their mother and father and start asking us for advice that you would only ask your parents. That's because we're sweet and I can keep a secret. I even keep secrets from myself.

There's sometimes no limit to what people will pay for their hair. But my husband would always say when charging customers, remember that people still have to pay their rent and buy groceries.

We are on the third generation now and it really makes me feel good having my grandson work in the salon. Family was very important to my husband. His mother died when he was five, so he never really had a family. All of his brothers and sisters were in different foster homes and he decided that when he got married and had a family, nothing would come between him and his family. It makes you feel good to work with your family and to know that your family wants to be around you. It's more like a family feeling here than business. It's like leaving home to come home. When I came back to the salon after my husband died, it was like a comfort zone for me. I didn't realize how much the people who worked for him really loved him.

For white guys my locks were exotic, but for Black guys

they were too different. If I met a Mr. Banker or Mr. Lawyer,

it was "I can't be bringing somebody with these little

Buckwheat things in her head to my corporate function."

SHANNON AYERS

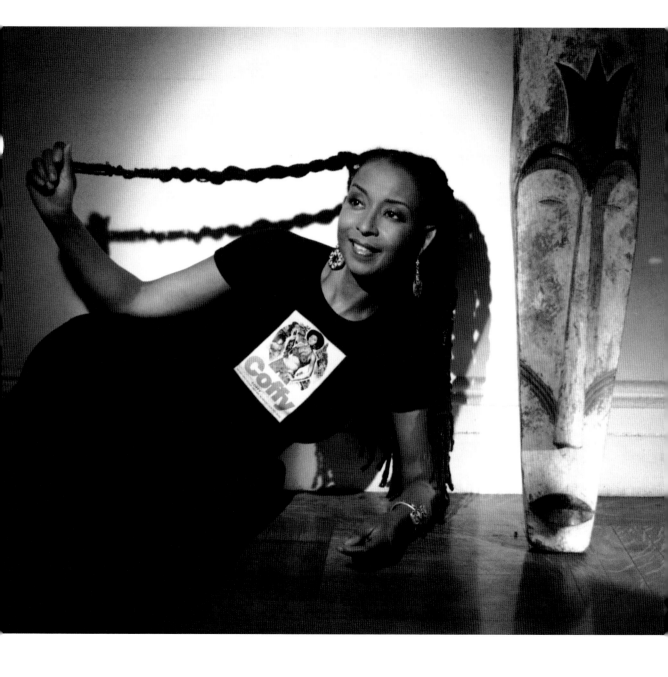

SHANNON AYERS, 46

{Hair Salon and Spa Owner}

I GREW UP IN PHOENIX, IN A PREDOMINANTLY BLACK AND Hispanic community. My mom wasn't good at styling, so she would always send my sister and me to someone else to do our hair. One lady used to press our hair and it was always unpleasant because it hurt; she would burn our ears with the straightening comb. This was when folks reinforced the notion that Black girls who didn't have "good hair" had "bad hair." But at a very early age my mom allowed me to express my own creativity and individuality.

When I was around ten, I wore an Afro. I didn't want to get my hair pressed anymore, I just couldn't take one more burn. My mom wore an Afro and she encouraged me even though other kids in the neighborhood really didn't wear that style until it became popular. A couple of my teachers weren't very supportive. They'd say things like, "Why are you wearing your hair all wild like that?" These were Black teachers and my mom was a very good warrior, she fought for her kids. She made each of us feel like we were her favorite child, which I think is a real gift. But she was fierce in that we grew up in the projects and she had to work hard as a nurse for everything we had. But if we were doing something wrong, other people had permission to tighten us up or let our mother know that we needed tightening up. But she protected us by allowing us to express ourselves.

One day a teacher was talking out loud, to no one in particular, but specifically about me, saying things like, "I don't know why these women let their kids walk around with wild nappy hair." I said to myself, "That's all right," and I went home and told my mother. My mother came right up to the

school and tightened her up. Tightened her up. I never had an incident like that again or heard comments that were inappropriate that could really mar a person's self-image.

After high school I went to Smith College and at Smith I wore a very short Afro. My senior year I let it grow out because I spent a summer in Ghana and wanted to have enough hair to have it braided. Then I started locking my hair in the early nineties because I felt that straightening and relaxing hair wasn't natural. There's nothing wrong with it, because I did it for many years, but it was always such a chore for me and I always felt like I was undergoing a silent death. But a lot of my friends didn't really get it. A lot of Black men did not respond favorably to my locking my hair. I'd be at a party with the rest of my friends and none of the brothers would come my way. None of them, none of them, none of them. Most of the folks who would try to hit on me were either white guys or other women. Not brothers. It took a while for that to change. For white guys my locks were exotic, but for Black guys they were *too* different. If I met a Mr. Banker or Mr. Lawyer, it was "I can't be bringing somebody with these little Buckwheat things in her head to my corporate function." Now it's perfectly acceptable for women to wear natural hair and to celebrate their beauty.

Eight years ago I bought Turning Heads Salon in Harlem. I was already a customer and thought it would be great if I could go to one place for everything: hair-styling, manicures, pedicures, and spa treatments. So I bought the salon and added a day spa and it's been great.

We believe in giving back to the community and assisting in education

by giving scholarships. Dudley Products, Inc., believes that

if we do well we should share with others. It's important to

pick up other people and bring them along. That's our legacy.

Eunice Mosley Dudley

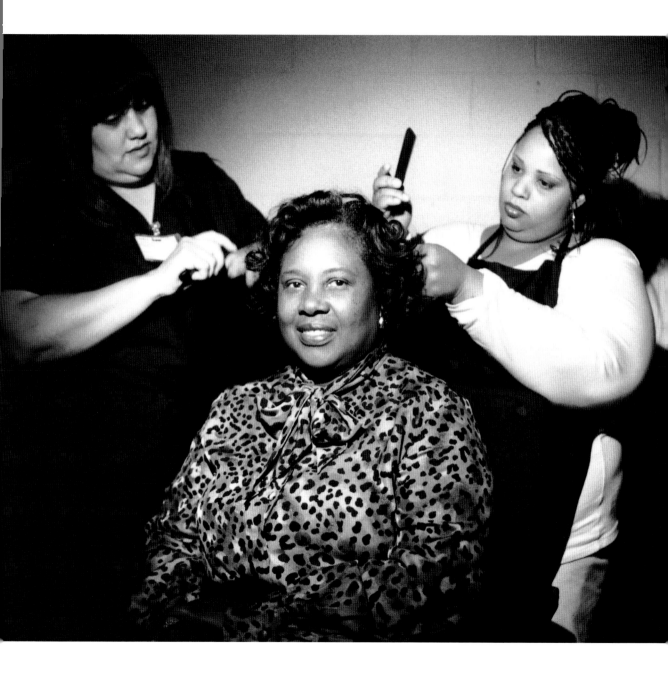

EUNICE MOSLEY DUDLEY, 62

{Cofounder and Chief Financial Officer of Dudley Products, Inc.}

I WAS BORN IN SELMA, ALABAMA, THE SEVENTH OF NINE CHILDREN. After I finished high school in 1960 I went to Brooklyn, New York, to live with my aunt and work for Fuller Products to earn tuition money for Talladega College. Fuller was a Black hair-care products company headquartered in Chicago, and they had several door-to-door branch locations in New York.

That summer while working for Fuller I met another salesperson, Joe Dudley, who was also a student at North Carolina A&T. It wasn't love at first sight, but I was attracted to Joe's strong work ethic. Being good-looking is fine, but I knew he wanted to work hard. Joe was about making money and saving money. We got married in 1961, and I went back to Greensboro to attend A&T while he finished college.

After college Joe and I went back to Brooklyn to work for Fuller and stayed there for five years. We opened a hair distributorship for Fuller Hair Care Products in 1967 in Greensboro, North Carolina, when Mr. Fuller convinced Joe to stay in the hair business after he considered quitting. We started eventually making our own products. In 1969 we also bought the rights to Rosebud Hair Pomade and renamed it Dudley Scalp Special.

Joe and I have been divorced for about five and a half years. I decided that I wanted to end the marriage, but I didn't want to end the business relationship because we built Dudley Products, Inc., together. Now we actually work together better; we don't have the personal pressures anymore. We have *business* pressures, but not personal pressures.

Our success and longevity over the years has had a lot to do with our having

a good mentor in S. B. Fuller, who started Fuller Products, and we have strong backgrounds in door-to-door selling. We came up the hard way, so we see challenges as things we have to overcome, not things that knock us out. That's what's kept us going, and we've been in business for thirty-seven years.

Black women are ever evolving and multifaceted. Styles change, fashions change, society changes, and hairstyles change, and you have to adapt. We listen to what our customers want, and we have a younger generation of people in our business who keep us up-to-date. We hire people with strong marketing and advertising backgrounds who keep us current with the business community, schools, and churches. We've also prepared our children for the business by emphasizing education, and they all work at Dudley. We emphasize family at our company and encourage not just the Dudley family, but all families. We give college scholarships to the children of employees and encourage them to come work for us after they finish college.

When I look at the Dudley legacy, we want our business partners, the stylists, and our students to be professional and business-minded. They've got to learn what it takes to run the business, not just work behind the chair. They've got to learn how to earn money, save it, and invest it. Not everyone is going to be a millionaire, but people need to be successful in their own eyes. We believe in giving back to the community and assisting in education by giving scholarships. Dudley Products, Inc., believes that if we do well we should share with others. It's important to pick up other people and bring them along. That's our legacy.

When I was fifteen, my grandmother passed away.

Before she died, she told me to learn to work with my hands.

She said that it is good for a lady to learn to use her hands . . .

∞

NANAAKUA ACQUAH

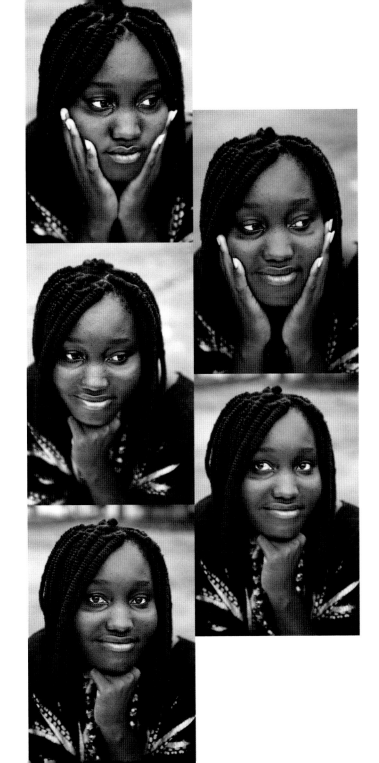

NANAAKUA ACQUAH, 25
{Hair Braiding Student}

I AM FROM KUMASI IN GHANA AND NOW LIVE IN ACCRA. AT the age of ten, I learned to braid my own hair. Before then, I wore my hair short. My mother likes kinky, natural hair. She likes it that way because she does not want to braid her hair. She just wants to keep her hair short, which is very Ashanti. Typical Ashanti women do not normally braid their hair. It is our custom to wear short hair and we sometimes use shea butter in our hair to oil it. Then braiding came in and people in the big cities usually like to braid their hair more than the people in the villages.

When I braid my hair I look different altogether. I have a large forehead and when I wear other styles I see my forehead and say "Ugh!" I don't like it. But I like braids because I can cover my forehead with them. I think I look beautiful in braids.

The style I am wearing today is called Dadaba braids. I like them because I look great in this style and it's not heavy. It's light and it's smooth on my skin and it took only one and a half hours to prepare, and I feel marvelous.

When I was fifteen, my grandmother passed away. Before she died, she told me to learn to work with my hands. She said that it is good for a lady to

learn to use her hands to work. My grandmother was not an educated woman, and she told me that I must learn to work with my hands, to create something for myself, to make something for myself and for other people. Today, everyone wants quick money. The whole world wants money, but if you don't have enough money for an education, you should learn to work with your hands. God has blessed our fingers. That is very important. That's why I decided to come to Accra to learn how to braid for a living. I like braiding because day in and day out new styles come in. When I braid, I use my hands to work hard. I use my hands to beautify someone by braiding and the person looks beautiful as I am now. Whenever I am braiding hair and someone tells me, "I like your hands," I think about my grandmother and what she said about working with my hands. I think about her always. My advice is that for anybody who doesn't have money to further their education, they'd better learn something. If you learn how to work with your hands, your future will be bright.

When we first found out the baby was a girl my husband, Derrick, said, "Okay, a girl. All right, that means we're going to have hair issues, self-awareness issues, body issues, and all this stuff."

LYNN RICHARDSON GODFREY

(WITH KAELA YVETTE MAE GODFREY, 2 MONTHS)

The first thing you do, of course, when you leave home
is assert your independence by cutting your hair.

YVETTE RICHARDSON

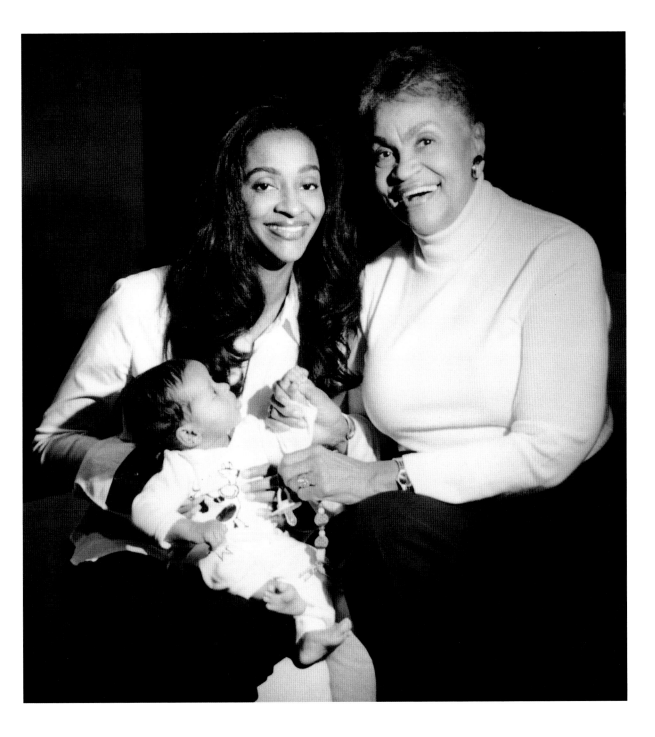

LYNN RICHARDSON GODFREY, 41

{Marketing Consultant}

THE FIRST TIME I GOT A RELAXER IN MY HAIR I WAS TEN. I was going on vacation to Barbados with some other families and there wasn't going to be anyone there to do my hair. After the relaxer my hair was really, really straight. But it was good for my trip because I could swim and my hair wouldn't get messed up like it would if I had pressed it. At the time, I thought it was kind of cool that all of a sudden you went through this process and your hair came out straight. But it's a sad commentary that my hair has been relaxed ever since then. Since I was ten. For thirty years, I've not worn my natural hair. When I take a step back from it, it's sad. I've thought about eventually going natural.

When I became pregnant and we first found out the baby was a girl, my husband, Derrick, said, "Okay, a girl. All right, that means we're going to have hair issues, self-awareness issues, body issues, and all this stuff."

Looking back to childhood, as a little girl growing up, for Halloween I always wanted to be a princess or a fairy. I would say, "Mom, do my hair like Marlo Thomas on *That Girl.*" I wanted straight hair with a flip. I never said, "Do my hair like Angela Davis or give me an Afro." It will be interesting to see how my daughter, Kaela, wants to wear her hair, because there's much wider acceptance of different types of hairstyles—braids, Afros, relaxed hair, whatever works for you. My attitude will be to go with what works for her. But I will not be in a rush to straighten her hair. I don't feel this need to send her to the salon when she's three or four. When she's able to articulate what she wants, I'll try to accommodate her.

YVETTE RICHARDSON, 73

{Child Development Consultant}

WHEN I WAS GROWING UP IN ATLANTIC CITY, NEW JERSEY, the salon was in the kitchen. A hairdresser came to your house with her utensils. My mom didn't need her hair straightened, but I had an aunt, Aunt Babe, who used the hairdresser's services. So I would go over to my Aunt Babe's house and she would get her hair shampooed in the kitchen sink and it would be brushed out and curled and I would be shampooed. I would go home and take a towel and try to get some of the oil out because it would be too straight and it didn't look right and I didn't like that. That's what happened until I went to college at Howard. The first thing you do, of course, when you leave home is assert your independence by cutting your hair. So at seventeen all this hair that my mother had tended so carefully came off and I had a poodle cut like most of the other girls. Every night you would pin up your hair in bobbie pins and these curls were all over your head and it was cute. That was popular then. I came home for Thanksgiving and my mother almost fainted: "Where is your hair? All that beautiful hair."

Over the course of my life, a hairstyle change has symbolized

how I am living out my destiny—what choices I've made

to reinvent or invent how I intend to live my life.

Harriette Cole

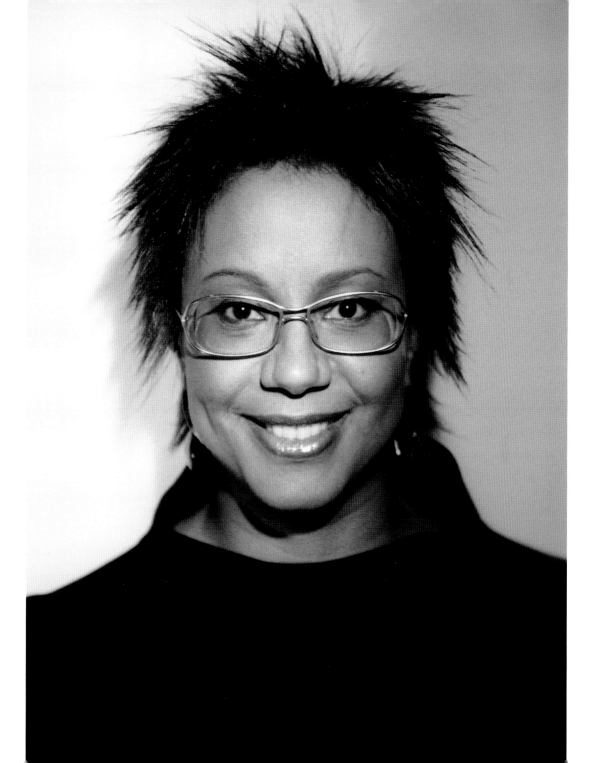

HARRIETTE COLE, 43

{Author, Syndicated Advice Columnist, and Life Coach}

I GREW UP IN BALTIMORE, MARYLAND, THE MIDDLE OF THREE girls, the daughter of a judge and a kindergarten teacher. I was named for my father, who was a very powerful man. He was the first black state senator in Maryland and the first black judge on the Maryland Court of Appeals—a trailblazer. My father wanted me to be like him and I wanted to be like him. But for him that meant perfection. I was pretty much a straight-A student. I got a couple of B's in my life and I remember in grade school when I brought home a ninety-eight on a test he asked me very seriously, "Where are the other two points?" That was our relationship.

There was a point in junior high school when I broke with my friends and it was very traumatic for me. Prior to that I had been painfully shy. I was very tall, very skinny, wore glasses, and had two long pigtails. But I cut my hair and wore it natural, and that began a rebellion and a coming into my own. So over the course of my life, a hairstyle change has symbolized how I am living out my destiny—what choices I've made to reinvent or invent how I intend to live my life.

From Baltimore to Washington, D.C., during the late seventies, early eighties when I was a student at Howard and modeled, architectural hair was very popular. The hairstyles were highly processed, colored, really interesting hair-show hair, and I had all kinds of really interesting hairstyles usually designed by people in the fashion industry. That was really fun.

I moved to New York in 1984 to work at *ESSENCE* magazine and I became immersed in an ethnic view of beauty, including having a deeper respect for

natural hair, and I decided to go natural. I was the lifestyle editor at *ESSENCE* for a long time, then the fashion editor. When I was the fashion editor, I wore my hair in different natural styles. I remember coming home to Baltimore in twists. To my family twists were pickaninny twists, an embarrassment. My father looked at me and said, "You can't come to my table looking like that." He was not kidding. But I wore my hair like that anyway. I liked the way I looked. But it was a really challenging time for me because my father, whom I loved so very much, was rejecting me.

Subsequently, when I was working on my etiquette book, *How to Be*, I remembered my hair battle with my father and started thinking about it with a bit of distance. I realized he was trying to protect me. His growing up experience told him that if you look conservative you'll have a greater chance of succeeding. I don't think he was wrong about that. But in certain fields in certain cities, ethnic hairstyles are acceptable.

With my current style, I thought I'd do something new, and I needed a look that would work on TV, that would be easy to maintain, that could become a signature and be fun. So I came up with this spikey style and I've had it for four years. People have suggested that I should have more conservative hair and that my hairstyles tended to be too radical for television. But with my spikey style, not only have I been on *Oprah*, the *Today* show, and *The Early Show*, I was also the host of a reality show in 2003 and I'm recognized on the street because of my hair, even from behind. It shows this interesting dance with my father over all these years—his rules versus mine.

The braids I am wearing today are called Bolga braids,

named after a town in the northern region of Ghana.

∞

GRACE KORJY

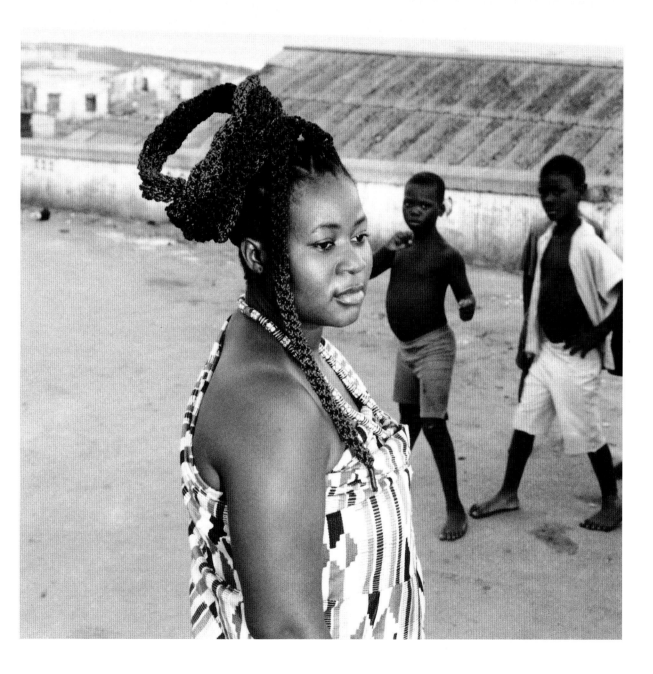

GRACE KORJY, 23

{Hair Braiding Student}

GROWING UP IN A VILLAGE IN THE NORTHERN REGION OF Ghana, for fun we liked to dance. The dance from my village is called *barsare*. It's a traditional African dance and it's just a part of your life. In the evenings when we do not have anything to do, we just gather around and dance.

I like braiding my hair because it is much easier for me than perming my hair. When I wake up in the morning I just have to tie my hair and go out to work. But if I permed my hair I would have to comb it and go to the salon all the time. I decided to learn how to braid hair, and I love doing what I do because it's easy to start a business in hair braiding because I do not have to buy hair dryers and all of the equipment you have to buy to do permed hair. I am

almost done with my hair braiding studies and I would like to start earning money from hair braiding first before setting up my own salon in Accra.

The braids I am wearing today are called Bolga braids, named after a town in the northern region of Ghana. The braids look like a basket, but they're called Bolga braids. I like this style; it's beautiful. They usually do such styles for girls who have just completed learning how to braid hair. They wear it to their graduation ceremony. It took seven hours to prepare my hair for today and nine people to braid it.

My father used to joke and say that if they

ever straightened my hair,

he'd come back and haunt them.

∞

FARAH JASMINE GRIFFIN

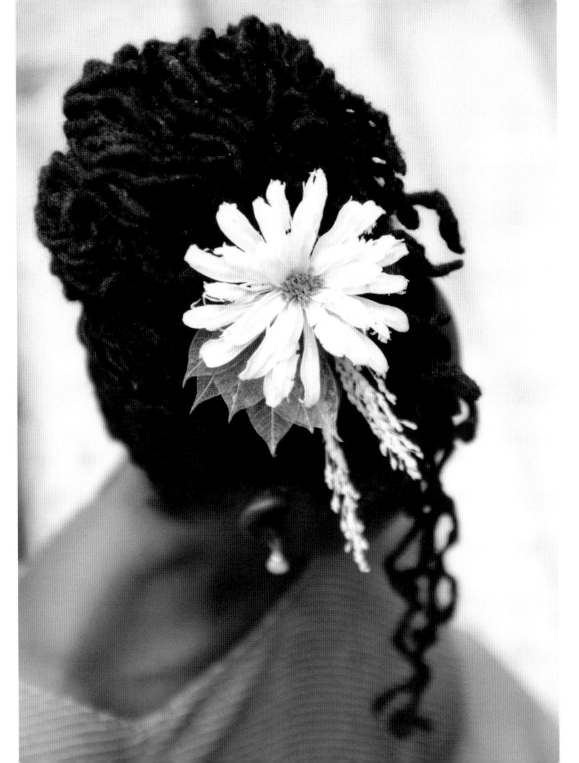

MY DAD WAS A BLACK NATIONALIST. WHEN I WAS BORN HE WAS in the Nation of Islam. He left after Malcolm X, but continued to have a nationalist's politics and aesthetic, so there was no hair straightening allowed in my family. I always had braids, Afro puffs, or an Afro. My dad died when I was nine.

In public school in Philadelphia was the first place I learned that my hair was nappy and that I was *Black*. I didn't have a sense of those things being "negative" until I went to school and learned that from other kids. My family, knowing that I was going to encounter that, stressed the opposite. I thought that being dark and having natural hair was beautiful until I realized not everybody had that same sensibility and kids started teasing me. In middle school I asked my mother to straighten my hair. After many fights and negotiations she agreed. The day she did it my aunts came over to the house; it was a big thing. My father used to joke and say that if they ever straightened my hair, he'd come back and haunt them. In our family hair was a big deal. Not texture of hair, but length of hair. The women were proud of their long hair. There was just a real investment in hair. So my aunts came and they instructed my mom in how to press my hair because she didn't press her own hair. It felt like a rite of passage. I think what I loved most was the time I spent with her. She'd wash it on Saturday night and put in little Bantu knots and in the morning she'd straighten it. We talked about everything: books; boys; sex; school; and about why I shouldn't have boyfriends before I graduated from high school. We'd talk about politics, family stuff. She told me about Dad and their romance. I was really curious about him, having lost him at an early age. I credit that "doing

my hair time" as being part of growing up and learning how to be a young woman. Sometimes there were certain older girls in the neighborhood that my mother would allow to braid my hair, but she always believed that if people didn't like you, you shouldn't let them mess with your hair.

My mother would save my hair because of the old sayings about not letting people get ahold of your hair because they might do something with it, like do roots on you, or the birds would make a nest out of it.

Because I was dark and had a lot of hair, people outside of my family always made me feel like the greatest thing of value to me was my long hair. In my teen years I'd hear, "She dark, but at least she has all that hair."

When I went to Harvard the first semester I didn't know what to do with my hair, so I went to a beauty salon for the first time. Through four years of college I alternated between braids and having my hair pressed. I loved the beauticians in the beauty shops in the Black neighborhoods in Boston. They were a safe space for me away from Harvard, which is a very alienating environment. They took care of me. They were very proud of us—those of us who were in college at the different schools. They encouraged us. It was almost a replication of my mother and aunts. It wasn't about hair. It was about affirming us. I wrote a piece about it called "On Hair and Harvard" in a book called *Blacks at Harvard*. I went to two educational institutions, one was Harvard and the other was the two or three Black beauty salons in the Black neighborhoods.

When people see my hair they admire it.

Even my colleagues admire my hair.

I feel like a queen in this hairstyle.

Maryam Ali

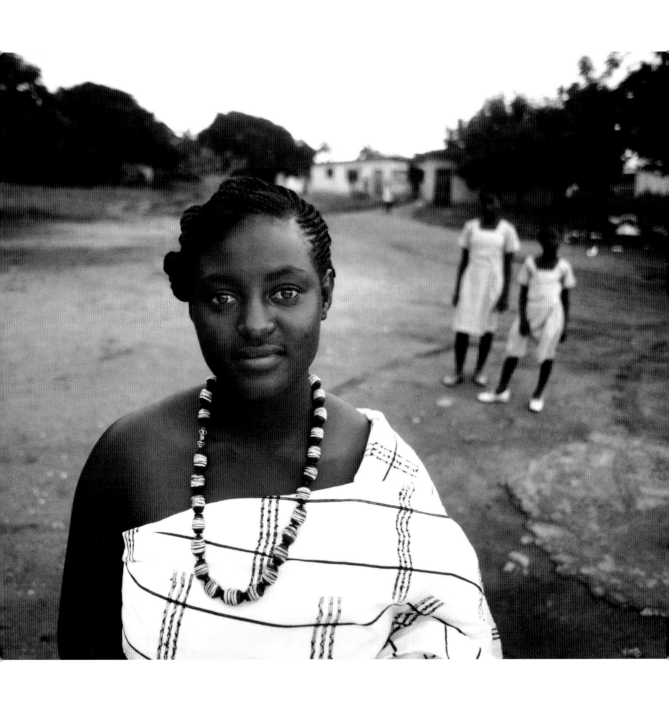

MARYAM ALI, 22

{Hair Braiding Student}

I AM FROM TECHIMAN, A TOWN IN THE ASHANTI REGION OF Ghana, the third of five children. I am Muslim and Muslim women are encouraged to braid their hair or go natural. Muslims believe it is a waste of time and money to go to the salon every week. It is better to use your time and money for more important things.

I started braiding my sisters' hair when they were small. Now, because I am not there, they have to cut their hair. My mother does not have time to braid their hair because she has to work the farm.

My auntie Alice did my hair today. The style is called Patience because in hair and in everything in life you have to be patient. That's why we call it Patience. Auntie Alice designed it and I think it looks nice on me. I think it looks like Africa. When people see my hair they admire it. Even my colleagues admire my hair. I feel like a queen in this hairstyle. Today, all of the customers who came here this morning said, "Oh, Maryam, your hair is so nice. Your hair is nice. Who did it for you?" So we are going to do Patience for some people today.

One person whose hair I admire here in Ghana is Auntie Nana. She's a very nice woman and she always says, "Maryam, the hair you did for me the last time I was here was so lovely and everyone was admiring it, so I want you to do it for me again." She fixes hair, but she comes here for us to do hers because she knows we do it better. I admire her because she's an older woman and I feel that if she tells me something, it is good for me. She tells me, "Maryam, learn how to braid hair because if you travel with your braiding skills you will make a lot of money, so learn it well. Learn it." She gives me a lot of advice and I know that it is true. I want to travel to other countries and make people look beautiful in braids. Everywhere I go I will have a job. I want to go to England, America, anywhere.

My style today is a high-fashion hairdo.

It's runway hair and very dramatic.

It grabs people right away and is a real conversation piece.

Nateile Justice

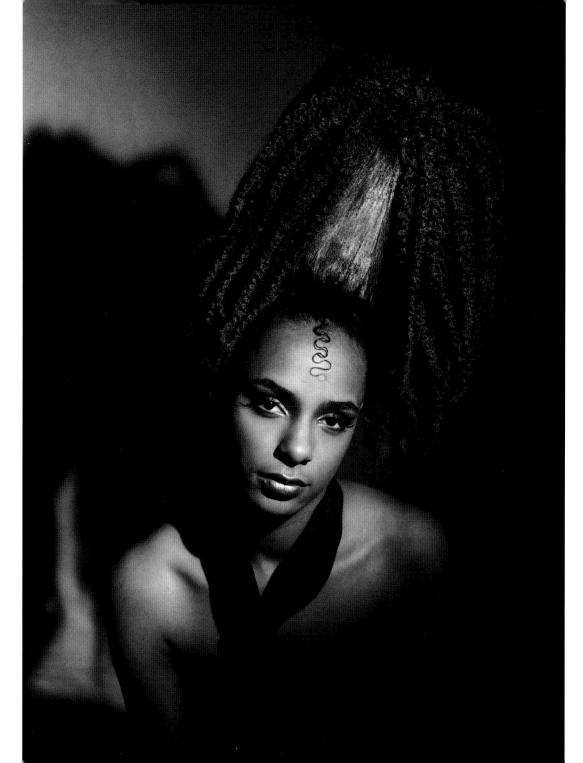

NATEILE JUSTICE, 19

{Stylist's Assistant and Student}

WHEN I WAS THREE, MY ADOPTIVE FATHER CUT OFF ALL MY hair and my sister's hair because he was a man and he didn't know what he was doing. He was by himself; his wife, our adoptive mother, had passed away and we wore hats to school for about a year because we didn't have much hair. I felt like a boy. Our hair finally grew back and we started wearing ponytails.

After my adoptive father passed away when I was nine, my sister and I moved to Philadelphia to live with his daughter. The experience was weird and awkward for us because we didn't know the people we were living with and didn't know anyone in Philadelphia. Eventually we ended up in foster care, and, between the ages of eleven and thirteen, I lived in about ten different foster homes. That was a stressful, miserable, painful, and depressing experience; I stayed to myself a lot.

We finally ended up with Ms. Abverian Ward, a foster mother in Philadelphia. Our first day with her she took me to a hair salon where her daughter Feanna, known as Fee, worked and introduced me to her. The next day Fee told me that I had to start working in the salon and I started shampooing hair. As I got older Fee taught me how to press hair. Working in the salon was fun because I always got my hair done every week and everyone at school was jealous of me because I didn't have to wear ponytails anymore.

The Wards treated us like spoiled brats. We got everything we wanted and they sent us to private school—Philadelphia Mennonite High School. That

school was great. I was in the choir and we traveled a lot. We went to Canada, Puerto Rico, South Dakota, Washington, D.C. We went everywhere.

I live on my own now with my four-month-old daughter, but I still work in the salon. I still shampoo hair, press, and assist in styling. I don't put chemicals in customers' hair because I don't have a license and don't plan to work in a salon permanently. I've never imagined myself working in a salon for the rest of my life. I hope to model or be a pediatrician. I love kids. There's just too much female hair drama in a salon. When it comes to women and their hair it's a big problem because they spend so much money on it.

Last year when I went to the prom I got my hair dyed for the first time. It was a red burgundy color and my hair was curly and pinned up all over. I wore a pink dress and pink shoes with diamonds on them. My hair and the shoes made the outfit. My look was extravagant and fun. No one at school had ever seen me dressed up like that.

My style today is a high-fashion hairdo. It's runway hair and very dramatic. It grabs people right away and is a real conversation piece. I hope it helps me in my pursuit of modeling. The makeup is beautiful and I feel beautiful. I feel like I'm finally starting something with my modeling. It might help me pursue my dream.

The funny thing is that I didn't have much hair until I was

four years old. I just had these little wisps of hair and

they used to call me "Blow Head."

My mother said that you could just blow across my head.

D R . E D I T H B O O K E R

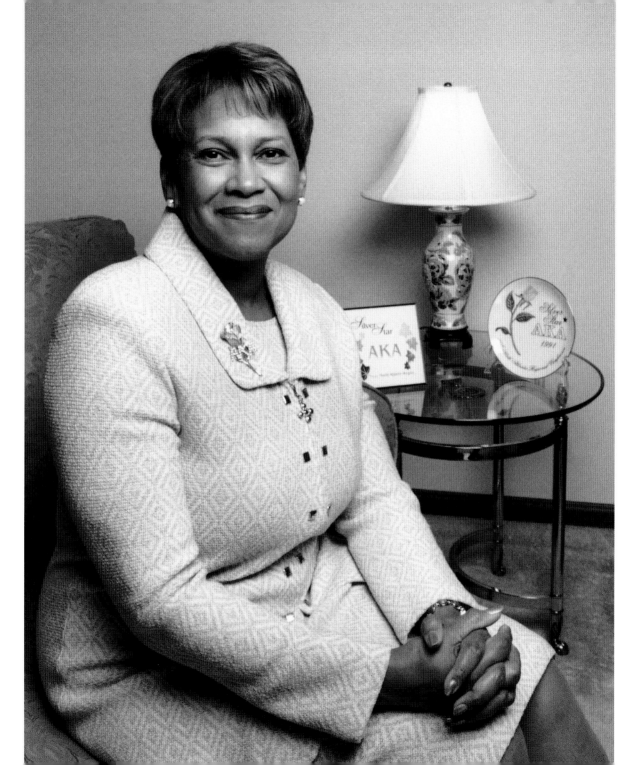

DR. EDITH BOOKER, 58

{Retired Higher Education Administrator}

I WAS BORN IN RICHMOND, VIRGINIA, AND GREW UP IN THE fifties and sixties. My father was a principal and my mother was a librarian and an English teacher.

The funny thing is that I didn't have much hair until I was four years old. I just had these little wisps of hair and they used to call me "Blow Head." My mother said that you could just blow across my head. My hair is fine. I didn't have the coarse hair that most people would attribute to Black people. So when the time came for the Afro, the bush, and all of the things that were indicative of us being Black, I couldn't go that route. At first it made me feel bad. I began to feel that my hair was letting me down. So at that point I started to wear it curly all over. My hair is naturally curly and that was about the closest I could get to having a bush or anything that looked like I wasn't trying to be white. But I got over that. I went to Howard University and I was in the midst of the political things happening there in the sixties. As I got older, I realized we are who we are, and we have what we have. Our hair doesn't necessarily say anything about who we are as people. I found a way to wear my hair that made me feel good about myself and that was the most important thing.

I've had different styles through the years. I had long hair at one time, but for the past fifteen or twenty years my hair has been short, very short. I think I look better with short hair.

I pledged Alpha Kappa Alpha sorority at Howard. I went to college with all intentions of becoming a member of AKA because my mother, who is now ninety-five and still driving, is an AKA. AKA was a mandate for me. When I was

a sophomore in the fall of 1965, Robin Gregory, who ran for Miss Howard and actually won, had a bush and the campus went crazy. There was so much debate about whether this was the right look. There was the sense that the sorority would never support anyone with a bush because we were the ones with the straight hair and the light skin and all those things attributed to us. There was a lot of controversy during those days, but I think people could see that we come in all colors, shapes, and sizes, and the sorority members do too to a large extent.

I decided many, many years ago that I didn't want to set my hair anymore, so now I jump in bed at night and get up in the morning and deal with it according to how it looks. I only go to the salon once a month to get my hair dyed. I started dyeing it because years ago my beautician said that if you dye your hair it makes the strands thicker and gives it a lot more body, and it did. I also use a curl relaxer called Curl Free that I buy in the drugstore and that I have been using since it came on the market in 1964. I'd been buying it at CVS until about a year ago and then I couldn't find it anymore and I just went ballistic. So I went on the Internet and found a place that sells it and now I order three boxes at a time. It works for me.

My older sister and I talk a lot about hair. Her hair is different, hers is coarser than mine. My sister started getting highlights in her hair a couple of years ago and she said, "You should get highlights." I said, "Naw, I don't want to do that." So we debated back and forth. Then in the earlier part of this year I needed a new look and decided to get highlights. And I've gotten lots of compliments on my hair. People say that the color makes me look "brighter." I don't know what that means, but I get a lot of compliments.

My Mohawk says, "I don't care."

To anyone passing by it says, "I couldn't care less what you think."

ANGELA WILLIAMS

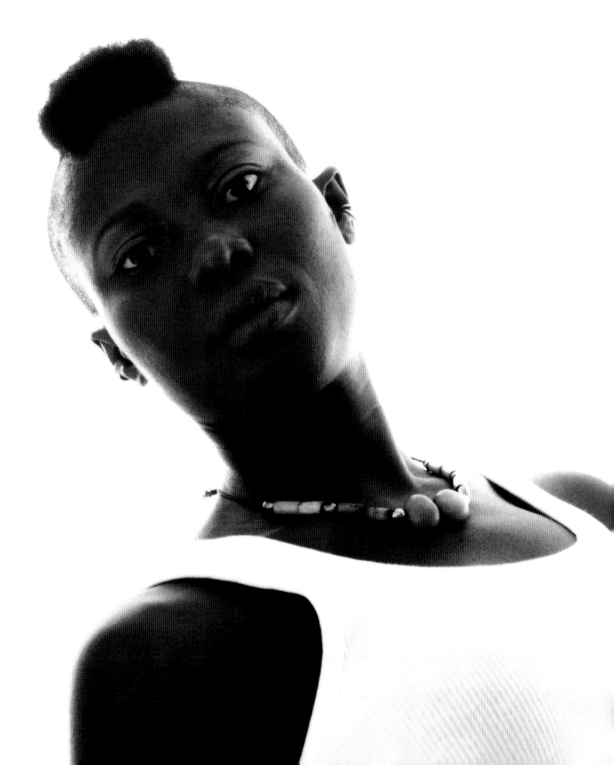

ANGELA WILLIAMS, 32

{Freelance Art Director}

HAIR IS FUN. HAIR IS TEMPORARY. I THINK IT'S MEANT TO be played with. I've had dozens of hairstyles, not unlike a lot of women. In high school in the eighties I had a different hairstyle maybe every couple of weeks. From French curls—finger waves on top of my head like Josephine Baker—to punk haircuts. One of my favorite hairdos was a punk haircut I got my sophomore year when I shaved the sides and the back of my head and just had a tuft of hair on top, and sometimes I'd straighten that or just have it sticking up. I've had every kind of hairstyle. You name it. My parents were okay with my hairstyles, maybe because I never got into crazy colors.

Before the Mohawk I had dreads. With my Mohawk, I think maybe, I'm having a pre-midlife crisis. I feel like I'm in high school again. A close friend has a Mohawk and he's the one who cut it for me. I wanted something different. It wasn't necessarily a Mohawk that I had in mind, but just something different. I'm not an outrageous type who can be spotted a block away, but I'm always doing something a little different than you'd expect. I recently quit a job that I had for several years as an art director at a major women's lifestyle magazine and now I'm on my own, freelancing and having fun, and just reveling in the fact that I'm now, for all intents and purposes, unemployed, so I can rock whatever hairstyle I want.

My Mohawk says, "I don't care." To anyone passing by it says, "I couldn't care less what you think." It's the kind of style you either love or hate, so I either get very positive reactions or really negative ones like pointing and laughing. But I get mostly negative reactions from Blacks. The first couple of days

I was annoyed with the negative comments, but then I started realizing where it comes from. I think Black Americans are very conservative and maybe even more conservative than other ethnic groups in this country. Most of us come from religious households even if we're not religious now as adults. I think there's also an idea of being concerned with how you present yourself to the greater society. I also think a lot of the negative reactions come from jealousy. Not the jealousy of wanting to look like me, but people might not feel the freedom in their own lives to express themselves. Not just regarding their hair, but they might feel that whatever they might be interested in expressing is being suppressed for whatever reason, so I think seeing someone who breaks out of the mold makes people uneasy and they might react negatively to that. Once this teenager yelled at me across the street, "You ain't P. Diddy, bitch!" Normally, I ignore them, but I went over to talk to him. He wouldn't own up to it. I asked him, "Where do you think you get the right to call me a bitch across Tillary Street?"

Black women either love my Mohawk or hate it. My mom hates my Mohawk. The word she uses is "frightening." She's a traditional Jamaican woman. She hated it when I got dreads. When she saw the Mohawk she didn't say anything. She just sort of looked at me with, "What's going on with your hair?" She wasn't pleased. She thinks I should just shave it off and start all over again. But I'm grown now.

It's the tallest and most unique hairstyle and outfit in

the competition here at the hair show in London. . . .

Even the outfit is made of hair.

T RACY P ORIS

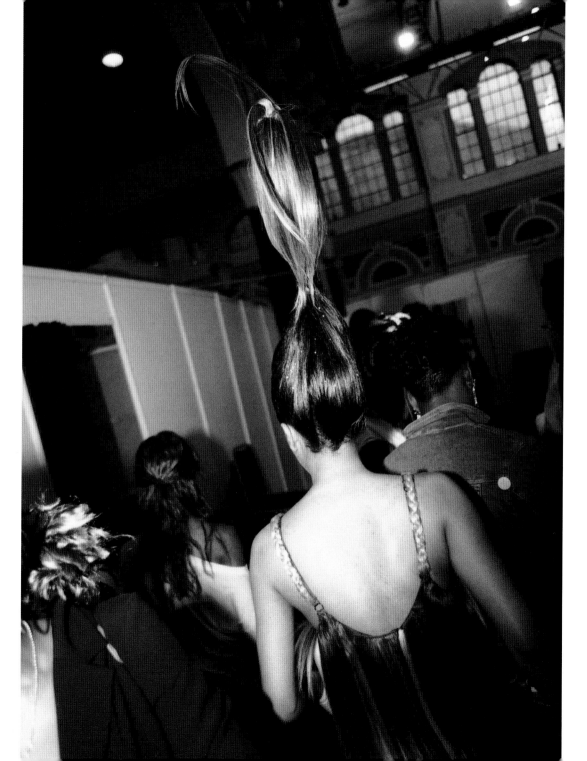

TRACY PORIS, 21

{Hairstyling Student}

I'M FROM THE SEYCHELLES ISLANDS IN THE INDIAN OCEAN. Growing up in the Seychelles is fun. The sun shines every day, the air is fresh and dry, and the people are very friendly. As a little girl I liked to wear two pony-tails and braids. That was the main thing for me when I was young. My mother would do my hair every morning and she would put coconut oil on my hair. Coconut oil makes your hair grow and my mother would also use it on her hair.

When my mom did my hair we would talk about life, school, and about growing up and about respecting your elders. We are really big on respecting elders back at home. That's very important in the Seychelles. If the elders said something, you just listened; you didn't reply. If you didn't respect your elders you'd get a whipping or some discipline from them, so we learned to be very polite.

My grandmother also used to do my hair when I was growing up. She lived right next door to us and she was a housewife and didn't work, so when my mother was at work, my grandmother would do my hair. I would sit in her lap and she would do my hair and I would cry, but she would still do it. She would tell me, "You're not going anywhere until I do your hair!"

Hair is the main thing of beauty for a woman. If your hair doesn't look good in the morning, you won't feel good. When I was small I used to like to sit and watch my mother do her hair. I thought it was really fascinating to watch her. I also loved playing in my mommy's hair. I would blow-dry it, comb it, and she would fall asleep.

I've always wanted to do hair since I was a little girl. I decided to take hair-dressing seriously when I was about sixteen or seventeen. I wanted to get into

hair because I like doing my own styles, I have a passion for hair. I have the patience for it and I want to make women feel good. When I finish doing a styling, I look at it and I feel proud.

I moved to London when I was nineteen to study hair, and I've been here a year and a half. Here in London they are more creative and they have different techniques than they do at home. As a stylist I would like to do both European and Caribbean hair. I would like to learn more about both hair types. I'd also like to do fantasy hair.

My favorite hairstyle growing up was wearing it dead straight. We didn't have the flatiron back home like they have here in London, so I had to put loads of cream in it to make it dead straight. I like that style because you feel light. It makes my face look good. The style goes with me. It feels light and free.

The style I'm wearing today was designed by Jawaad Ashraf in London and it's exciting. I was very nervous at first about wearing this hairstyle and outfit, but I felt more comfortable once I put it on. It was a thrill. It's the tallest and most unique hairstyle and outfit in the competition here at the hair show in London. It's very different. Even the outfit is made of hair. The hair for the dress was sewn into my bra and feels like a carnival costume. The crowd and judges really loved the design and it won first prize in the competition.

Winning first prize was like a dream come true for Jawaad and me after all of his hard work. He really deserved to win. It was my first time winning anything in such a big competition. It was great.

I'm always asked about this hairstyle.

I haven't named it, but I should because it sets me apart

from all other hairdos and it's my logo.

MISHON MISHON

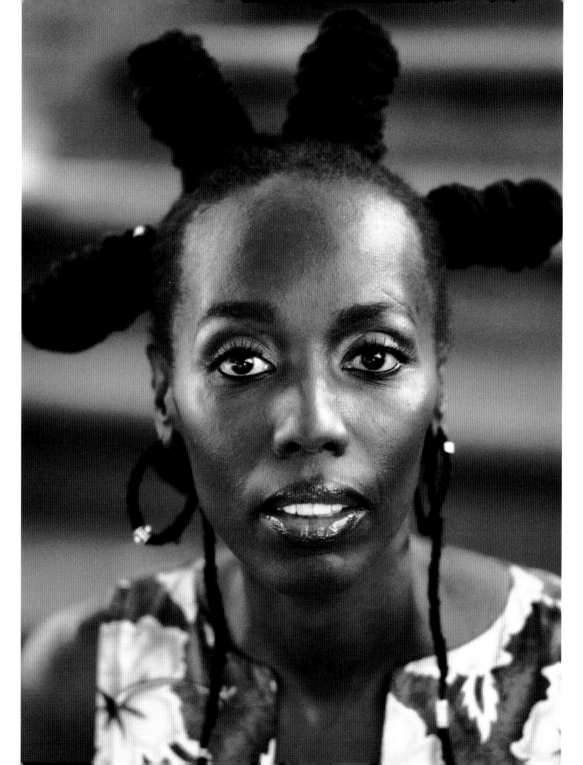

MISHON MISHON, 40

{Hairstylist}

I GREW UP IN BROOKLYN. I STARTED PRACTICING TO BE A stylist on family members' hair, doing simple things like greasing the scalp. Scratching the scalp was an old Southern ritual that soothed the elders. "Girl, come here and scratch my scalp for me, I'll pay you," an older person would say to you. My sisters would fight for that task. I'd also do the hair of the younger people in the family, corn braiding the children's hair for fifty cents or a dollar. My desire to be a hairstylist started there. I was about nine then.

There was a little dresser in my grandmother's room, and in the bottom drawer there were old stockings, with runs in them, that we would use for stocking caps at night to stretch the kink out. That was pre-pressing. If you were a preadolescent you didn't get your hair pressed unless it was a holiday. There was a whole ritual to what time of life you got your hair pressed. My first press was for picture-taking day in third grade, and that was the first time I had bangs.

Getting my hair pressed for the first time, I felt like I was going to be on the scene, I had grown up, I was going to be accepted. I wanted my hair to move. I think the madness about Black hair and women is that we are infatuated with hair that moves. If it doesn't move, it just doesn't meet our standard of beauty. Men, too, are fascinated by hair that moves. So pressing gave us hair that was flowing, blowing.

In the early eighties I wore my hair in braids. People would ask me who did my hair and I told them that I did. They'd say, "Well, can you do my hair?" I never took it seriously until I started putting extensions in my hair. I

tried my hand at some individual extensions and the women would stop me all day long. I thought, "I can do this for somebody else." I started from that point on putting extensions in people's hair, going to their homes and taking it seriously. I partnered with a sister I went to high school with and we opened a natural hair-care salon in Brooklyn. It was called Designer Braids.

I'm always asked about this hairstyle. I haven't named it, but I should because it sets me apart from all other hairdos and it's my logo. I knew that I needed a logo that would make a statement, but I couldn't find one. I searched and searched and I said, "What's going to speak to culture? What's going to speak to hair? What's going to speak to culture, hair, pride?" Whew! That was deep. I couldn't find anything that already existed that spoke to those things for me, so I created something myself. Some people call them Nubi knots, but they're really exaggerated lock knots. I wanted to diversify the lock look. Everybody thinks that when they get locks they're stuck, but you don't have to get stuck. I took my locks and coiled them up into four standing knots going down the center of my head. I thought, "Okay, this is unique." I tried it out on the street and it was a showstopper. People stopped me, took my picture. That's happened with other styles I've done, but with this one it was crazy.

If my mother could see me now,

she would not be happy with my hairstyle. . . .

It's not our tradition. We got this from white people. My mother would

say that a good Ghanian woman has to be simple.

Juliana Manfou

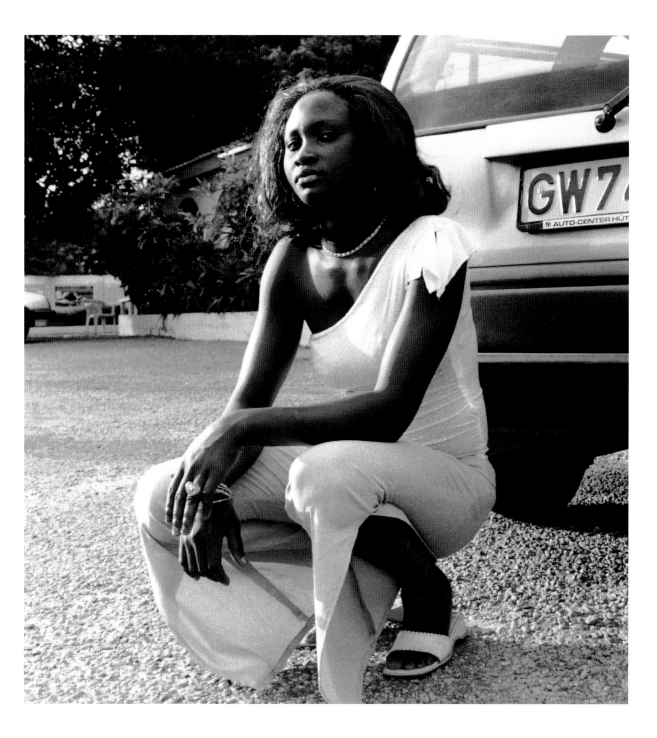

JULIANA MANFOU, 20

{Hairstyling Student}

AS A CHILD FROM THE TOWN OF ASUOM IN THE EASTERN region of Ghana, I wore my hair short and then I wore cornrows. I wore cornrows because they make your hair grow. Now, I wear hair extensions instead of wearing my natural hair because when I wear my natural hair the hair dryers damage it. That's why I prefer extensions.

My mother died in the year 2000 and I have decided now to come to Accra to become a hairdresser and to start a new life. I want to make money here and send it home to my father. My mother never saw my hair straight like this. When my mother was sick she told me that when she got well that she would take me to learn hairdressing. But my mother died. On her deathbed, she told me that I should be a hairdresser. That's the first time I had the idea to be a hairdresser. Now, it's my life's dream.

The very day my mother died my auntie said that she would take care of me. I asked her to send me to school, but she said no. When I lived with her I did not go to school. I just stayed at home, farmed, and read. That's it. It was difficult for me living with my auntie.

I have chosen the burgundy color for my hair because it goes with my black skin. I get a lot of reactions from men on the street. They say that it's beautiful. It attracts men to Black beauty. This hairstyle prepares me for marriage. It says to people that I'm a big girl now. I saw this style on a calendar and I liked it and wanted it. I said, "I want that."

If my mother could see me now, she would not be happy with my hairstyle. She wouldn't like my hair. She didn't like makeup and nails and things like that. It's not our tradition. We got this from white people. My mother would say that a good Ghanian woman has to be simple. To be respected you have to be simple. If my mother saw me now, she would cry. She's turning over in her grave right now. But I'm a woman and I have to make a new life. I have to live my own life.

. . . I remember when I came away from the hair salon I cried.

I cried and I let my hair undo itself and I locked it after that.

That was probably the turning point I needed . . .

Debra Priestly

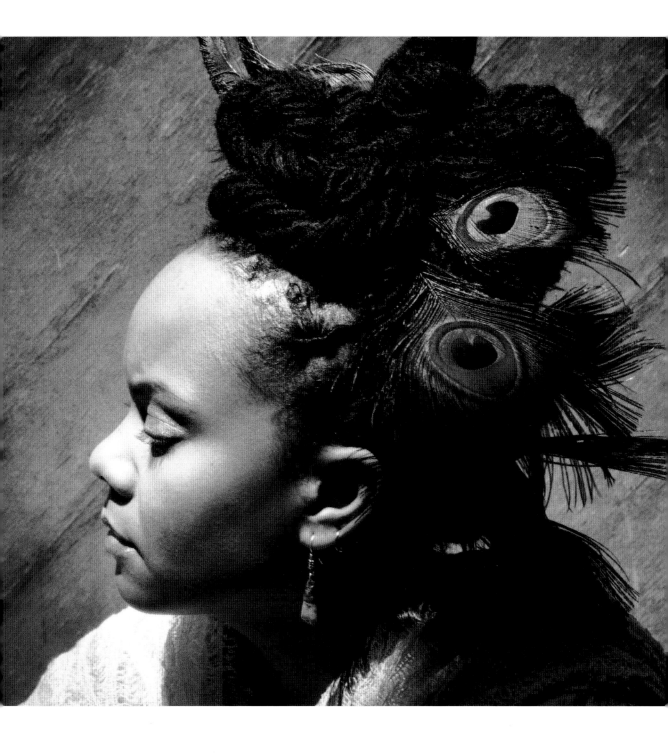

DEBRA PRIESTLY, 42

{Artist and College Professor}

MY MOTHER'S MOTHER SAVED ALL OF HER HAIR IT SEEMED. I knew she was saving it and shortly after she died and we were going through her things we found bags and bags of hair. I don't know why she saved it. It's a mystery to me. We didn't talk about it. I don't know if there was a superstition about it, but it was certainly saved. I was surprised that she had saved so much of it. I wondered why, but she wasn't around to ask.

It really stuck in my mind and many years later it became a part of a series of assemblages in my own work called *Preserves*. I used actual found objects including some jars found at my grandmother's house and hair combined with some other elements. *Preserves* has to do with how we collect things and preserve them. There is some of my grandmother's hair in some of the canning jars.

Prior to having locks, my sisters and I started experimenting with natural hairstyles. We'd never had perms, but we would press and curl our hair. In high school we started wearing braids, plaits, and cornrows. My brother wore an Afro. We even started braiding other people's hair in college for a little extra cash. In about 1984, I started wearing plaits a lot more and in 1986 I started locking my hair out of love for natural hair. I had been wearing plaits for several years anyway, so it just seemed like a natural progression. I didn't know anyone personally who had locks and I didn't know what to do with them. I grew up in Ohio, and I wasn't even around a lot of people who were wearing braids. Back then I think most people were locking their hair for religious reasons; there weren't that many people locking their hair because they

wanted it to be in a natural state. The first time I saw them I just thought that they were really gorgeous. I think it was one big experiment.

There was a short while after undergrad when I took my plaits out and I decided to curl my hair again and I felt so unlike myself. I realized that for me keeping it natural is a form of expression that is very important to me and is connected to free thinking. It was influenced by the fact that I had gone back home to Ohio to live for two months before I went off to graduate school at the Pratt Institute in New York, and I think it was part of my environment just being in an area where most people press their hair. And I remember when I came away from the hair salon I cried. I cried and I let my hair undo itself and I locked it after that. That was probably the turning point I needed to do whatever I'm doing now. I like the natural texture of hair. It just feels right to me.

When I went down to New Zealand as an artist-in-residence, some people were really fascinated by my locks. But a lot of Maori people there have locks and have had them for a long time. A lot of gang members there also wear locks. Some people were afraid of my locks because they aligned my love for wearing black clothes and my love for wearing locks with people they were afraid of, so I got mixed reactions. A lot of people would just reach for them, especially if I went into a yarn shop. My hair is past my waist so sometimes I'm not aware of it. I usually just gently take it back. People get so offended when you tell them that you don't want them to touch your hair, so I try to do it gently.

My dad just about every day would say,

"Hair is a Black woman's crowning glory. You must always take

care of your hair. Child, what are you gonna do with that hair today?"

Ebony Jo Ann

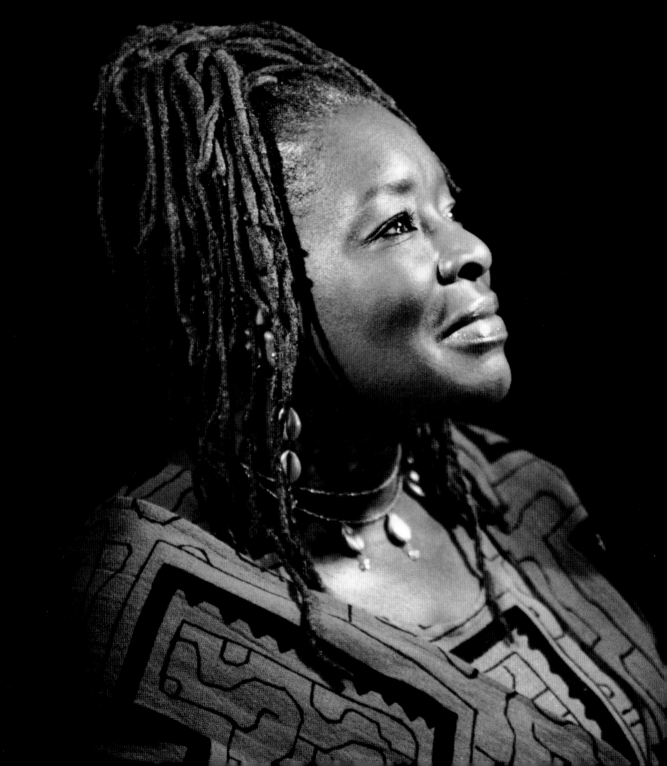

EBONY JO ANN, 59
{Actress and Vocalist}

HAIR HAS ALWAYS BEEN VERY IMPORTANT TO ME. HAIR WAS always very important to my family, especially my dad and my mom. My dad was a very spiffy dresser and had his own private closet. He used to repair his own shoes and block his own hats. My dad just about every day would say, "Hair is a Black woman's crowning glory. You must always take care of your hair. Child, what are you gonna do with that hair today?" For him there was no question about how your hair was supposed to look. My mother always had long luxurious hair.

When I was growing up my mom favored the Mamie Eisenhower bang, so we all had bangs. We used to do our mother's hair because she used to have really long hair. We would say, "Mom, we're going to do your hair. We're going to make you sharp," and we'd ultimately tangle her hair up in the comb and we'd do her hair up in what we called an upsweep. That's how we got her hair all tangled. But our favorite hairdo was what we called a pageboy. In our early teens we would have our hair rolled on paper bag rollers and our hair would have a nice little bend that would fall around our shoulders.

I've never had chemicals in my hair in my entire life. About seven years ago I began noticing that my hair was thinning right at the top of my head,

and I started telling the young lady who was doing my hair about the thinning and at first she didn't believe me but then she began noticing it. She asked me if I wanted to start locking. I said, "Will dreadlocks save my hair?" She said, "Oh, yeah. That's the last chance for long hair." I'll never forget that as long as I live and that's what we did. This is all my hair.

Locks are my antenna to God. I believe that locks are the natural state of Black hair. In fact, I know they are. I changed spiritually after I started locking my hair. The first thing I found out was that we as a people know very little about our hair. After I locked my hair, I learned about the real texture of my hair, how it really grows.

My hair is my connection to my people, it's my connection to my family. It has connected me to my entire line, all the people before me and all the people after me. My hair has connected me to my past and present. It's like being a griot. Everyone in my family has followed me in most everything that I've done in terms of natural things—natural medicine and now natural hair, even down to my grandbaby, who wants to lock his hair too.

The beauty salon is the one great thing we get to share as African-American women. It's therapeutic.

ANGELA GARNER

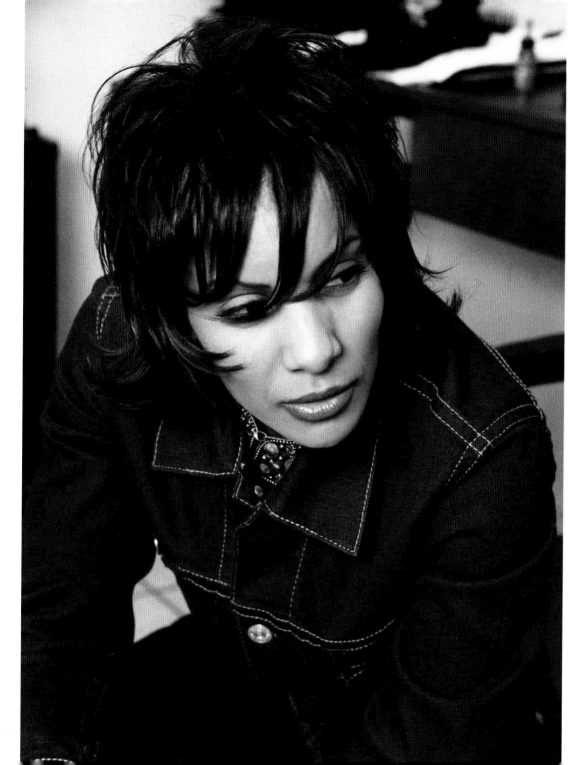

ANGELA GARNER, 37

{Actor and Writer}

I WAS ABOUT TEN YEARS OLD THE FIRST TIME I REMEMBER going to a salon with my mom and hearing, "Sister, you ain't got *good hair*." I had to have my hair pressed and I got a Shirley Temple press and curl. I remember having that feeling that it was special because as a little girl you don't necessarily know what beautiful is, but you understand special.

One of my favorite memories was getting my hair done for my high school prom at McKinley Tech in Washington, D.C., back in 1984. Of course you want to look good all the time, but the prom is one of those occasions where you want a hairstyle that's a little more than you normally would get. Your adrenaline starts to flow and you go to the salon with an anticipation of getting something more. Even though you may leave the salon looking the same—beautiful with a great hairdo—it's psychological. You really think you're getting something more, but the hairstylist has been giving you a phenomenal piece of work all along. But you're thinking, "This is something really special." It's the attitude more than anything else. It's a state of mind.

In the beauty salon we're able to capture the moment that is satisfying to our minds, spirits, and our souls. It's a necessary moment and it's so important because the women in a salon come from all walks of life. We deal with so many things outside the walls of a salon, that when we're there we push those things behind us and it's almost like our spirits connect on that one common bond—hair. The beauty salon is the one great thing we get to share as African-American women. It's therapeutic. It is a setting where women are motivated, they open up and talk about their burdens, like men. Men can be a burden sometimes. Today's Valentine's Day and I don't have a date, and I'm in the salon with other women and they don't have dates either, it's a cool thing. I'm not by myself. It makes it easier. We're all connecting on that level where we're still beautiful and we're coming here to look beautiful for ourselves. I have to please myself before I can please someone else. I have to love myself first before I can love someone else.

My mother forced me into wearing this because it's my parents',

Tony and Sonia Chir's, entry in the competition at

the Afro Hair and Beauty Show in London.

J ENNESHA C HIR (LEFT)

. . . Participating in hair shows is fun. I particularly love walking down the

catwalk, showing off my hair, looking at the crowd, seeing their reaction.

T RACEY M AITLAND (CENTER)

This style is really extravagant, makes you feel like the center of

attention, and is a good confidence builder if you're not used to doing

something like that.

D ONELLE G RANT (RIGHT)

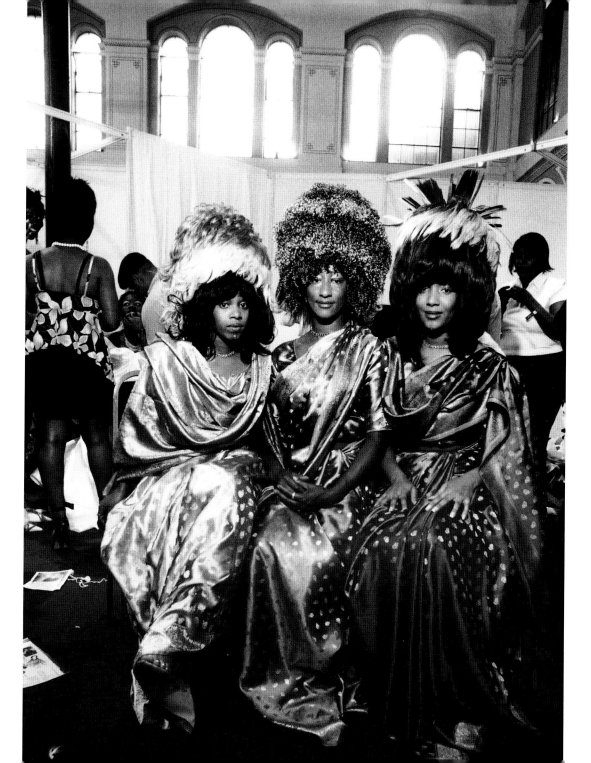

JENNESHA CHIR, 22

{Hairstylist}

I STARTED WORKING IN HAIR SALONS IN EAST LONDON AT fourteen as a Saturday Junior. I washed hair and made the clients' tea. Now I work with my mom and dad at their salon.

My favorite hairdos for my clients are pinups. You can create so many different things. Pinning hair up is not just about pinning it up. It's the way you pin it up and how you pin it up. And obviously if you've got color in your hair and you pin it up, it's going to have a different effect. The color has to match the person and their personality. It all depends on your profession and how you are as a person. Obviously, certain styles and certain colors don't work everywhere. There's a time and a place for everything. What you wear in a pub or bar would be different than what you'd wear in the courtroom.

But when it comes to my hair, I don't really have time to pin it up. I tend to like my hair straight. My hair is naturally curly, but I don't like curly hair.

My hairstyle today is very heavy on my head. My mother forced me into wearing this because it's my parents', Tony and Sonia Chir's, entry in the competition at the Afro Hair and Beauty Show in London. It took my parents a month to prepare the designs. The hairstyles are made with balloons, which were first covered with paper then fabric. Then hair was added. It's all human hair. My parents have not named the style, but we are supposed to be Asian brides. The crowd was very surprised by the style. We got a lot of screams.

TRACEY MAITLAND, 32

{Mentor}

I GREW UP IN SHEFFIELD, ENGLAND. MY HAIR WAS THICK, and I wore an Afro, long plaits, big plaits. Normal styles, really. Because my hair was pretty thick, it used to always hurt when it was combed, so I don't have any fond memories of that. My mom and dad would both comb our hair. It was like a ritual for us.

My hair is short and I like short hairstyles because they're more creative. You really can't do much with long hair. I love putting color in my hair. My favorite colors are red, burgundy, and today my hair is lilac. I'll have to try lilac again after the competition. Lilac is the color of my bedroom. It reminds me of the beach. Red and burgundy have always been my favorites. I mainly buy red and burgundy clothes. They reflect my personality, which is fiery, vibrant, and very active.

I think that participating in hair shows is fun. I particularly love walking down the catwalk, showing off my hair, looking at the crowd, seeing their reaction. Today's hairstyle makes me feel really special.

DONELLE GRANT, 22

{Banking Administrator}

I GREW UP IN EAST LONDON. MY MOM USED TO ALWAYS DO our hair and we never liked it. She always pressed our hair. My aunt would also press my hair for me. Every time we went to her house she'd get the hot comb out and we'd have to hold our ears down so that they wouldn't get burned. She would press our hair in the kitchen with the hot comb on the stove.

My hair was natural until the age of twelve when I was in secondary school and I had a chance to relax it and go with the trends and have all of the latest hairstyles like my friends.

I'm thinking of going natural now but it's a long process. But nowadays it's more stylish to do natural hair, whereas back in the day it just used to be cornrows and fat plaits. No one teased me back then because all of my friends had natural hair too. Plus, I didn't have nappy hair. I actually had silky natu-

ral hair, so I could accommodate all of the hairstyles and you wouldn't be able to see the difference, really. You'd put a little gel in it and that's that.

I enjoy going to the hairdresser and my daughter enjoys the experience too. She's only three and she knows what a hair salon is. Her hair is natural, so she goes to get her hair washed. She even requests different hairstyles. So she's not your average three-year-old. She learned that from her mom.

Wearing fantasy hair in the hair show is great. The attention is brilliant and it's good publicity for the salon. But the style is very painful and very heavy to wear. Apart from that, I really enjoy it and I'd love to do it again. This style is really extravagant, makes you feel like the center of attention, and is a good confidence builder if you're not used to doing something like that.

This style is named "Alice braids" after Alice Dasebu, who operates

the hair braiding school I attend in Accra.

REBECCA ADWU

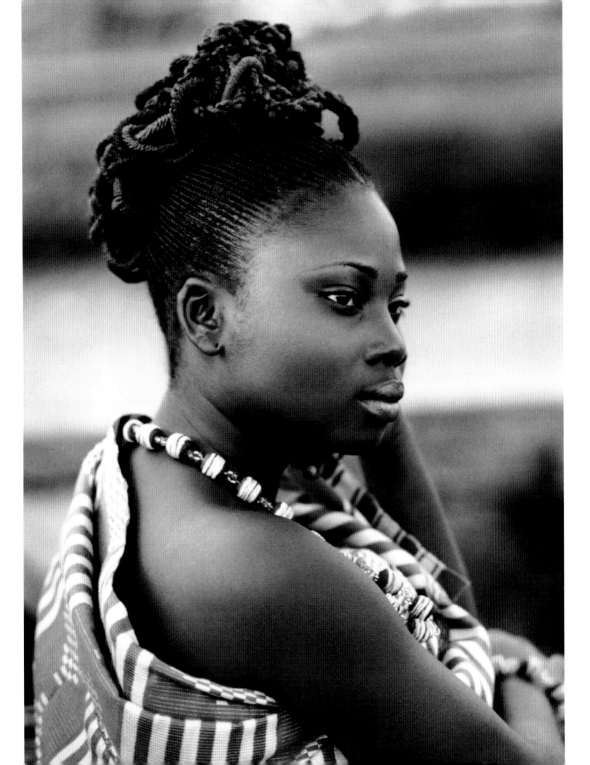

REBECCA ADWU, 19

{Hair Braiding Student}

I THINK MY BRAIDS TODAY ARE VERY BEAUTIFUL. I HAVE A lot of male admirers. They think I look like a queen. This style is named "Alice braids" after Alice Dasebu who operates the hair braiding school I attend in Accra. They used to braid this style with real hair some time ago. Now they braid it with hair pieces instead of real hair. It's a traditional Ghanian hairstyle.

I am from Awutu. Awutu is an area in the central region of Ghana. The Fanti people live there. I grew up in a village there with my parents. I am the sixth born of six children. My father and mother still live in Awutu; they farm and have livestock. But all of my brothers and sisters now live in the city, in Accra.

I like living in Accra and learning how to braid hair here because I am exposed to the different cultures and different hairstyles, but in my village I wouldn't have the chance to learn new hairstyles. My sister is a hairdresser, and she advised me to learn hair braiding so that we can open our own salon one day. Hair braiding is fun because women come and get their hair braided and afterward they are so grateful. They say, *medasi*, thank you.

As a child, my hair was cut down low because I attended a school that required that our hair be cut short, and my mother did not allow me to have braids or to do anything to my hair. I got my first style when I turned eighteen years. I then permed my hair at a salon. I wanted to keep my natural hair,

but it was difficult for me to maintain my natural hair, so I got a perm so that my hair would be soft and easier to manage. I now braid my permed hair. I like braids because I have very thick hair and it is long and it usually gets wet because of the weather, so I decided to braid it to make it easier to maintain. I think it's good to perm hair, but it depends on the texture of your hair. When I was a child my mother encouraged me to perm my hair. My mother thinks that permed hair is good; it is a symbol of wealth. It is a symbol of an enlightened person.

When I first started learning how to braid, when a customer came in I was asked to start braiding the person's hair from the back and then I would make mistakes and then my teacher would send me away and give me a doll and ask me to practice with the doll's hair so that I could learn to braid properly. I was really surprised at myself and amazed at how I was able to pick it up, because when I started I didn't know how to do anything. I was very embarrassed and used to feel bad about messing up because my teacher would scream at me and ask me to undo all of the braids I had done. Sometimes my teacher would speak to me in a very cruel manner and all of my friends would understand because it's something you have to go through to be perfect.

There're no words to explain the feeling I have when I've helped

a woman see the woman she thought she could be

from the woman who first came into the shop.

∞

Sonia Mullings

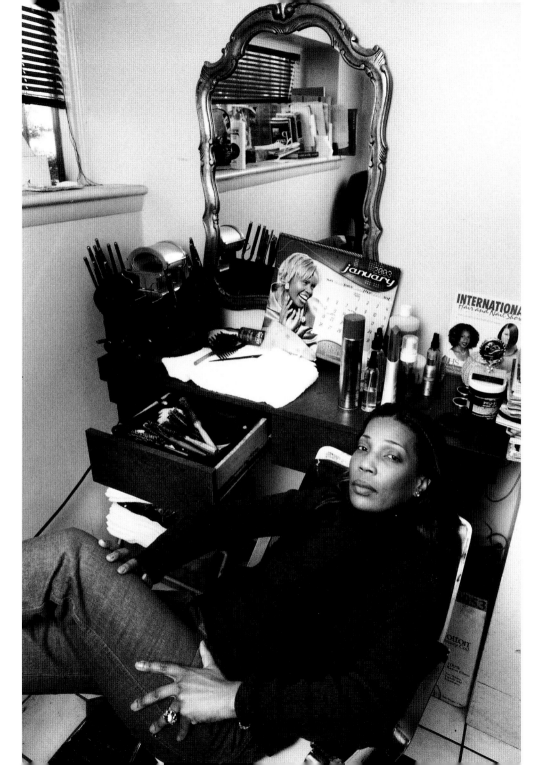

SONIA MULLINGS, 42

{Hairstylist}

I BECAME A HAIR STYLIST BECAUSE I NEEDED SOME DIREC-tion in my life. I didn't finish school and I didn't have a degree and I had a son. I was on public assistance and I knew I wanted more than that. I prayed to the Lord for direction and the first place I went for a job was a beauty shop. I asked the owner if they needed someone to clean up and the woman said no, so I went to another beauty shop and the gentleman said sure, and I eventually became a shampoo person and it unfolded from there. I fell in love with hairstyling. It was something that I felt was expressing me.

The African-American beauty salons are special even though they may not always be plush. The salon is a place where women can come in and sit down and be heard and finally express how they're feeling. I've found being in this business for so many years that women don't come to the salon for just a hairdo. The hairdo is secondary to having someone focus on them. That's really the meat of it. These women are busy hustling for the dollar, trying to take care of their families, and they don't have time to address themselves. Oftentimes, they put themselves on the back burner. And the majority of the women don't complain about the time they spend in the chair because the time is spent with them getting into themselves and indulging in conversation

they wouldn't get to have elsewhere because there are so many things pulling at them. It's really about women finally having a moment when they can express what they want. It is a form of letting their hair down and taking their shoes off.

Sometimes a woman may not even know what style she wants but she'll express how she's feeling and the stylist will listen and be more attentive. The stylist wears so many different hats, and she'll have the patience to listen to the client and to interpret what they're saying, then the stylist will express her creativity on the person's head.

There're no words to explain the feeling I have when I've helped a woman see the woman she thought she could be from the woman who first came into the shop. She is so impressed that time and cost are no longer issues. She actually gets to be the woman she wanted to look like, which then affects her conversation, her tone of voice, her disposition, how she feels about herself, how she tips me, and how she will go home and address her children and her husband because something has blossomed in her that she had an idea could blossom, and seeing it blows her mind.

My favorite hairstyle is the style I am wearing today.

It is a traditional Ghanian style called Akwyelebi.

In my language, Twi, that means "together as one."

SAFIA EIJAHAM

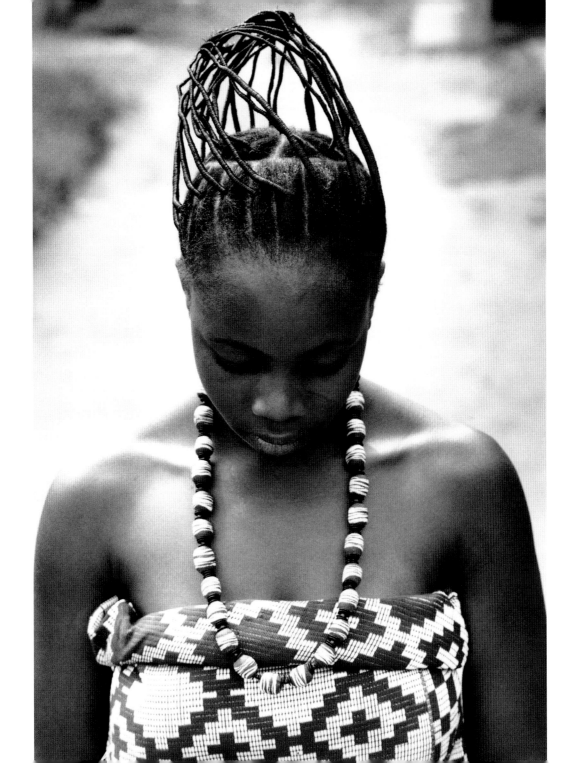

SAFIA EIJAHAM, 25

{Hair Braiding Student}

I AM FROM KINTAMPO, GHANA, AND IN MY VILLAGE WE HAVE a yam festival and during the festival we do cultural dances and we enjoy ourselves. For the festival we braid our hair in any style we want. It's a big celebration. The festival is held every year in October at harvest time.

I started braiding my own hair at the age of eight. I taught myself. It was God's gift to me. I would also braid my mom's hair and other people's hair too for them. Braiding is special because braiding is less expensive and we do not have to use chemicals or dryers as you do when you perm hair. But whether you perm your hair or not, you always come back to your traditions. Traditions are important.

I want to braid hair for a living because I have no one to help me out in life. I want to be able to take care of myself. I do not want to have to depend on anyone to take care of me but myself.

My favorite hairstyle is the style I am wearing today. It is a traditional Ghanian style called *Akwyelebi*. In my language, Twi, that means "together as one." I think it's beautiful. Women in rural areas, in the villages, would wear this style. The style symbolizes that in life you cannot always think alone. Sometimes we need advice from others. If you want to do something, you may need another person's help in order to achieve your goal. You do not have to be in conflict. When two people come together there is happiness, unity. We must be willing to have peace and unity in every place. Typically during festival periods women would wear this style because we want everyone to come together to celebrate. That's why we say, "Together as one."

I have blue hair today because I'm wearing blue

at the Luton Carnival. This is the twenty-ninth anniversary

of the carnival and my hair has to match my shoes,

has to match everything.

∞

CORENE CAMPBELL

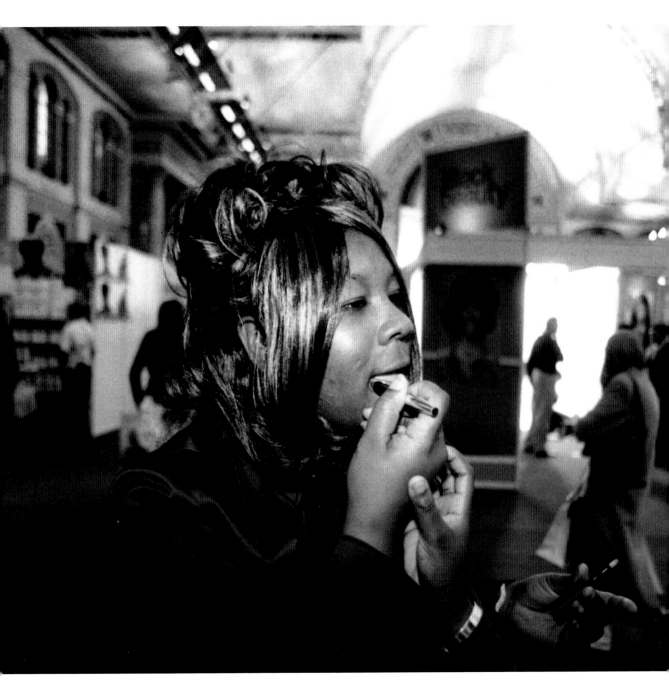

CORENE CAMPBELL, 24

{College Student}

I'M FROM LUTON, ENGLAND, AND I'M BLESSED BECAUSE MY mum is a hairdresser, so I've always been exposed to hair and I'm from a big family. Actually, my whole family, they all do hair. My uncle's a barber and my aunties are hairdressers. So my mum inspires me. She always does my hair. I have blue hair today because I'm wearing blue at the Luton Carnival. This is the twenty-ninth anniversary of the carnival and my hair has to match my shoes, has to match everything. That's why I wear outrageous hair colors.

I think my first hairstyle was at about the age of three, and growing up I've had hairstyles with green, yellow, extensions, one side blond, one side black. Last year for carnival I had pink and white hair because I was wearing pink and white. The year before that, I had red and black hair to match my red and black outfit, so by now I've gone through the whole rainbow. I love different colors. I've been this way all my life. You have to be brave to wear these sorts

of colors in your hair because not everyone can carry it off. My mother has blond hair now. She experiments with hair too. We're very creative. I change my hair every month or every few months. I change my hair because I'm really extroverted. I'm comfortable with myself, so that makes me more confident to change my hair. I might put a smile on someone's face if they're sad and then see my hair. Or they might hate it, but it's something to talk about.

When I was blond, I thought actually, "If white people can do their hair a certain way, then Black people can do their hair that way too." So I decided to wear black hair in the back and blond in the front. And the saying is true: "Blondes have more fun!" When I had blond hair, oh my God! I attracted *everybody*. All the men were pinching my bottom and everything. I'd say {laughing}, "Get away from me!" Trust me. Blondes have more fun. Because my mum's hair is blond now and she havin' funnnn! I'll definitely be a blonde again.

My braids remind me of my youth. They make me feel good.

On the street, young men . . . ask me, "What's up? What's yo' name?

What's yo' number?"

MARILYN A. HOPKINS

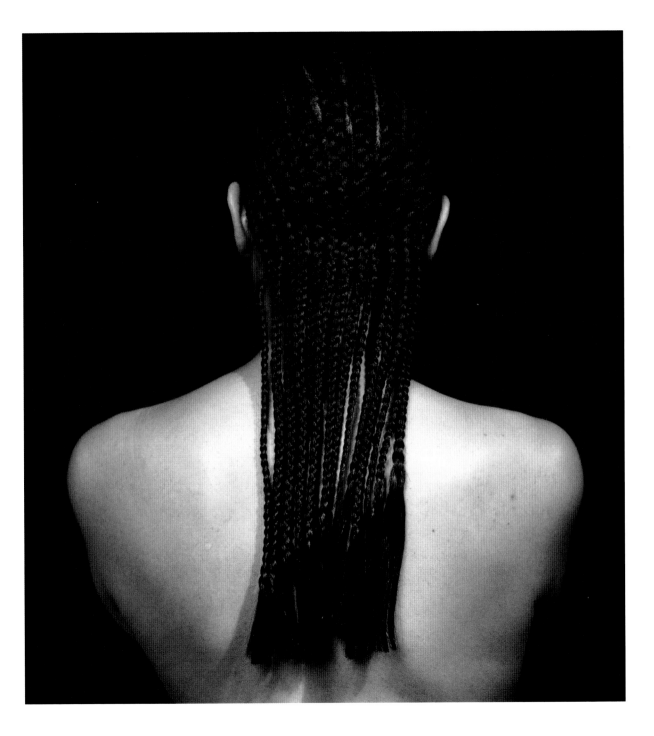

MARILYN A. HOPKINS, 39

{Event Producer}

MY BRAIDS REMIND ME OF MY YOUTH. THEY MAKE ME FEEL good. On the street, young men look at me and ask me, "What's up? What's yo' name? What's yo' number? You got kids?" Everyone swears I'm twenty-something.

My parents met and married at Grambling State. My mother, Beverly Dawson Hopkins, was Miss Grambling 1959 and my dad, Bob Hopkins, was an All-Star and is in the Louisiana Basketball Hall of Fame, and was one of the first Black NBA players. So I'm the product of a college queen and a basketball jock.

I've always had really thick hair. I was the person in my family out of my two sisters who had the "good" hair because it was sort of curly and didn't nap up quite as quickly, whatever the heck that all means. Growing up in New Orleans and going to Catholic school, my sisters and I always had either ringlets or braids. My mother would always wash our hair on Saturday and curl it on Sunday for the week.

We later moved from New Orleans to Seattle when my father became assistant coach then later head coach for the Seattle Supersonics. In Seattle I always kept my hair in a ponytail or braids. I didn't get my first perm or haircut until I got to college at the University of Washington. I wanted a perm because everyone got perms and I'd never had one. I was playing collegiate volleyball and I was the only black volleyball player at the university, and when I would blow-dry my hair or straighten it with an electric hot comb, the white players would say, "Your hair is smoking! What's wrong with your hair?! Oh my God!

Your hair is going to catch on fire!" I'd say, "There's nothing wrong with it, it's just the heat coming off the hair." People would trip.

I later ended up attending Southern University in Baton Rouge and graduated from Grambling. At Southern and Grambling I began doing people's hair in my dorm room. Because I had a lot of hair I had the whole Farrah Fawcett thing going on, and I would wash and set my hair. I learned about setting hair in Louisiana because it's so humid there you have to set your hair in order for your curls to stay. With just a blow-dryer your hair would go flat. So everyone wanted me to do their hair. I ended up giving perms, cutting hair, setting hair, braiding hair, and straightening hair. I would charge people something really cheap like twenty bucks. That's how I made ends meet.

I started modeling while I was at Southern and continued modeling after college when I went back to Seattle. I had that whole Whitney Houston hairstyle—the curly bob with the bangs and eventually all bob. I tried every hairstyle there was. After a while I got tired of that and in 1991 I cut off all of my hair. Since then I've kept my hair really short because it's easy. I was used to my hair being the defining part of me and my mother would say, "You've got the best hair. You can't cut your hair. You *can't* cut your hair." My mother is from Shreveport, Louisiana, and hair is such a big deal down South for women. "Men don't like women who don't have hair," my mother would say. I'd say, "I'm cutting it off. I don't care."

Jeanette gave me this very ornate style because
I have the personality for it. I'm very outgoing,
I love people, and, most of all, I love myself.

Lettice Graham

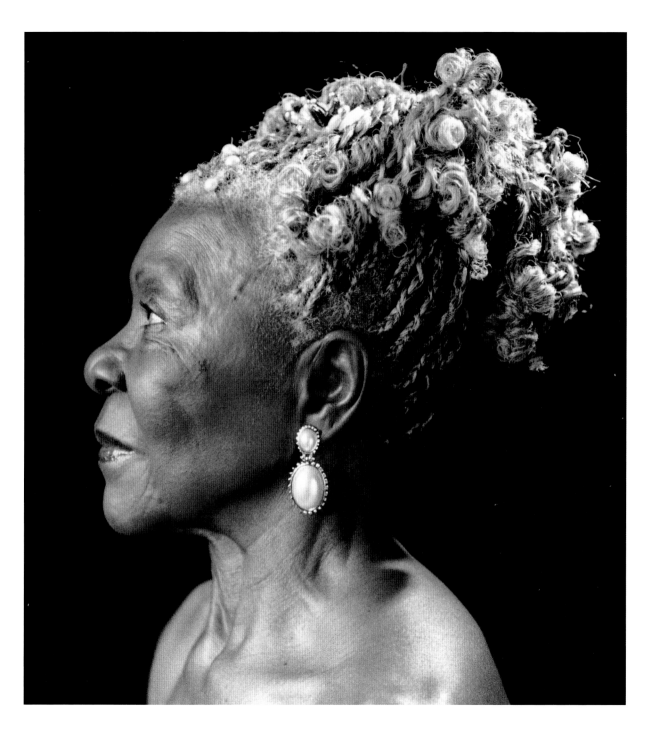

LETTICE GRAHAM, 82

{Retired Telephone Company Service Representative}

I GREW UP ON A FARM IN JACKSONVILLE, NORTH CAROLINA, the eighth child in a family of eight. I came to New York in 1947. I was a young person and felt it was time to go out on my own and I came to New York. I was happily married for thirty-one years until my husband passed away. I have no children, but I was a mother to many others. I have many nieces and nephews who always called on me, so I was available to them.

When I was a child, my aunt used to braid my hair and she would braid it so tight that I couldn't laugh for three days. Growing up, I also used to do my friend's hair with the hot comb until we got older and we started going to the hair salon. I've always wanted to make sure that my hair looked good and I still like for my hair to look good, which meant that my hair was shiny and healthy with good body.

One of my favorite hairdos was when Diane Bailey at Tendrils in Brooklyn did my hair for a photo shoot for *ESSENCE* magazine that featured me in 2004. It was called an African curl. People would see me on the street and ask me who did my hair. I was overjoyed with the style.

I decided to get braids because I swim five days a week at the Hansberry Recreation Center in Harlem on 134th Street and braids are more conven-ient. Wearing my hair natural or in braids is less work for me. My style now saves me a lot of work and time. When I get up to get dressed, I don't have to worry about my hair, so I can get dressed in ten or fifteen minutes.

Jeanette Massey at Vivienne's in Harlem does my hair now. It takes Jeanette about four hours to prepare my hair in this style. After she shampoos my hair, she blow-dries it, twists it, and then rolls it up. She then puts each curl in hot water; the hot water makes it curl and the curls last for about three months. At my age, I still want to look young, but I think it's more appropriate to wear my braids up. I've been getting it done this way for about a year and a half now.

Jeanette gave me this very ornate style because I have the personality for it. I'm very outgoing, I love people, and, most of all, I love myself. I'm also an Aquarian and Aquarians are very loyal and tend to have a lot of friends. I have lots of friends and I'm the president of my swim club. I'm really blessed. I get an awful lot of compliments with this style. People tell me that my hair is so pretty.

This style now makes me feel more youthful. When I look in the mirror, I feel beautiful inside and out. But wearing braids is just a convenience thing for me. I'm not trying to make any political statements at all.

To me, age is just a number. I feel like I'm eighteen years young. I have lots of energy. I usually start my day at 4:45 a.m. I do a half hour of crunches, a half hour of yoga, and a half hour of sit-and-stretch. So I do an hour and a half of exercise before I go to the pool. I'm very active and even at my age I still continue to meet new people. It's so beneficial for seniors to stay active.

ACKNOWLEDGMENTS

{FROM MICHAEL AND GEORGE}

Queens would not have been possible without the support of many people. We'd like to thank our amazing agent, Victoria Sanders, for giving us this brilliant idea; Victoria's excellent assistant, Benee Knauer; our editor at Doubleday, Janet Hill; Clarence Haynes, Tracy Jacobs, Kim Cacho, Maria Carella, Lesley Krauss, Kimberly Nordling-Curtin, Rebecca Holland, Bill Thomas, Michael Palgon, and Stephen Rubin at Doubleday; Shannon Ayers of Turning Heads Salon and Day Spa in Harlem for her time, endless support, and excellent consultation on this project, Lee Priestly of Turning Heads for her exceptional lock work, Dekar Lawson and the rest of the staff at Turning Heads; Bunny Plaskett, Joe Plaskett, Akemi Plaskett, the Plaskett family, Walter Lucas, Bill Staton, and the entire staff of Hair Styling by Joseph's in Manhattan; Veronica Forbes of Veronica's Beautyrama in Harlem; Feanna Smith of Fee's Hair Salon in Philadelphia; Mishon Mishon of Mishon Mishon Natural Hair in Brooklyn; Natural Motions Hair Salon in Washington, D.C.; Sonia Mullings (of the former Details by Sonia Hair Salon in Washington, D.C.); Angela Garner; Tony and Sonia Chir of Dimensions Hair Studio in Ilford, England; Alice Dasebu and all of the women of her hair braiding school in Accra, Ghana, for their incredible patience with the Americans; Cherie Johnson of New York for styling Tonya

Lewis Lee; Secunda "Jabez" Gumbs for his great photo assistance and positive spirit; Sidra Smith for her multifaceted help from day one; Uncle Nana, Dorothy Yeboah, and Michael for their help in navigating Accra, and their superb English translation skills; Lafayette Jones of Segmented Marketing Services, Inc., and *Urban Call* magazine for tremendous advice; Matthew Jordan Smith; Peggy Mazard, Jovanca Maitland, and Trina Felder at *ESSENCE*; Robin Whitley; James Ford; Rachel Hastie; Bruce Bowen; Christopher Lockhart; Brian Keith Jackson; Dr. Ian Smith; Jawole Willa Jo Zollar, Amy Cassello, and all of the fantastic dancers of Urban Bush Women for their talent, time, and inspiration; Verna McKenzie and Juliet Coley of the Afro Hair and Beauty Show in London, England; David Humphries of Hair Wars; the Bronner Brothers International Hair Show in Atlanta, Georgia; the International Hair and Nail Show in Secaucus, New Jersey; Karen Williams; Kimberly McLurkin Harris; Angela Turner; Dennis Decker; the Studio Museum in Harlem; the Smithsonian Institution's Anacostia Museum and Center for African American History and Culture; and last but not least, for their amazing makeup artistry and tireless effort, Lysette Drungold, Karen Robinson, Zanthony Preston, K. Roc, Ruth Johnson, Octavio, Aeriel Payne, and Ayana Gray.

Finally, thank you to all of the women who shared their stories with us.

{FROM MICHAEL}

∞

Thanks to God, from whom all blessings flow. To everyone who has helped me through this journey: my family, my great-aunt Clara, volunteers at Urban Shutterbugs, Gary and Kit Putnam, April Sauerwine and staff of Black & White Custom Photo & Digital Lab, Sherrie Wallington, Brenda Hall, Wanda Jones, Steve Newsome, Lorenzo Nicholson, Mr. Raymond, and Mrs. Delores Bell.

To George Alexander, working with you has been an awesome experience for me. I thank you for this collaboration. And to my daughter, Kamari, Daddy loves you!

{FROM GEORGE}

∞

There were so many people who helped me personally in making this project a success. I must thank God for giving me the grace to let my passion be my profession and for always being in the boat during the storms; my parents, Lionel Alexander, Jr., and Velma Griffin Alexander, for their boundless support; my father for his never-ending editorial guidance on almost everything I've ever written in my life; my mother for her never-ending prayers; my brother and sister-in-law, Lionel Alexander, III and Cynethea Alexander, for always being there; my brother Alton Alexander and nephew Alexander Adrian Scott for being great always; my aunt and uncle, Lynwood and Georgie G. Davis; my cousin Lynwood G. Davis; Charlotte Greene;

Damian Bracy; Lolita Rhodes Cusic; Fred and Tracy Watson; Chris Burge; Larry and Rachel Strawn; Al and Carole Bush; Jeff and Rachel Hastie; Craig and Lori Woolridge; Adisa; Harris Bostic II; Manfred St. Julien; Martin and Akieva Jacobs; Kelvin and Celia Walker; Alan and Katrina Smith; Steve Rohr; Gregg Baty; Charles Reese; Munson Steed and *Rolling Out* magazine; Dr. Michael Lomax; St. Clair Bourne; Camille Billops; Warrington Hudlin; Toni Judkins, Mike Goudreau, and the crew at VH1; Alesia Powell Montgomery and company at BET; George Tarrant at State Street Films for his great support always, Tad Smith; Keith Brown; Curtis Simmons; Doug and Dede Traynor; DeWayne and Anita Reed; Tony and Melanie Pinado; Karl and Sheila Humphrey; Monique Jones; Caroline Clarke; Cliff Virgin III; Warner Johnson; Lourdes Liz; David Asomaning; Bernard Bell; Cassius Titus, Esq.; Lisa Davis, Esq.; Ryan Smith, Esq.; Debra Butler; Tamara Fields; Lori Ann Pope and the Sunday dinner crew; Afi Tamakloe; Kwabena Haffar; Seth Mann; Kendall Steverson; Furaha Norton; Duana Fullwiley; Vince Pepe; Vicky Rocchi; the Alexander clan; the Mobile crew near and far (you know who you are); Adline Clark at Black Classics in Mobile; the sweet ladies of the Les Charmes; the Morehouse gang; and the Frederick Douglass Creative Arts Center.

To Michael Cunningham for working your magic with the lens. It has been great fun working with you. We'll have to do it again, brother! *Medasi!*

ABOUT THE AUTHORS

MICHAEL CUNNINGHAM is the originator/photographer of *Crowns* and the photographer of *Spirit of Harlem*. He is the executive director of Urban Shutterbugs, a photography and mentoring program for inner-city youth. His works have been featured in museums across the country. To view more of his work, visit www.mcphotog.com.

GEORGE ALEXANDER is the author of *Why We Make Movies*. He has written for VH1, *Black Enterprise, Daily Variety, American Legacy Woman*, and *Savoy*. He is a graduate of Morehouse College and Columbia University Graduate School of Business.

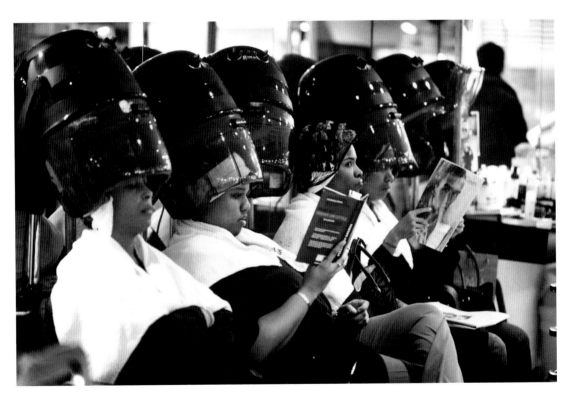

Hair Styling by Joseph, New York City